IMAGES
of America

BEAR MOUNTAIN

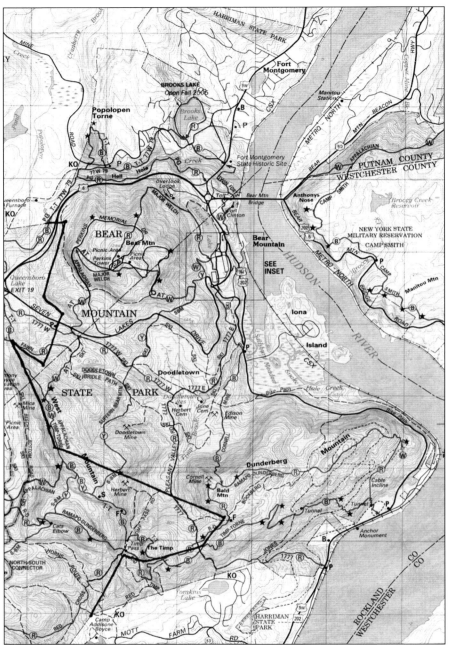

PARK MAP. Straddling Orange and Rockland Counties, Bear Mountain State Park is bordered on the north by the United States Military Academy, on the west by Harriman State Park, on the south by Stony Point, and on the east by the majestic Hudson River. Within its borders are West Mountain, Popolopen Torne, Dunderberg Mountain, the remains of Fort Clinton and Doodletown, part of the Appalachian Trail, Iona Island, Hessian Lake, numerous trails, museums, a zoo, and the Bear Mountain Inn. (New York-New Jersey Trail Conference.)

On the cover: See page 95. (Palisades Interstate Park Commission.)

IMAGES
of America

BEAR MOUNTAIN

Ronnie Clark Coffey

ARCADIA
PUBLISHING

Published by Arcadia Publishing
Charleston SC, Chicago IL, Portsmouth NH, San Francisco CA

Printed in the United States of America

Library of Congress Catalog Card Number: 2007936896

For all general information contact Arcadia Publishing at:
Telephone 843-853-2070
Fax 843-853-0044
E-mail sales@arcadiapublishing.com
For customer service and orders:
Toll-Free 1-888-313-2665

Visit us on the Internet at www.arcadiapublishing.com

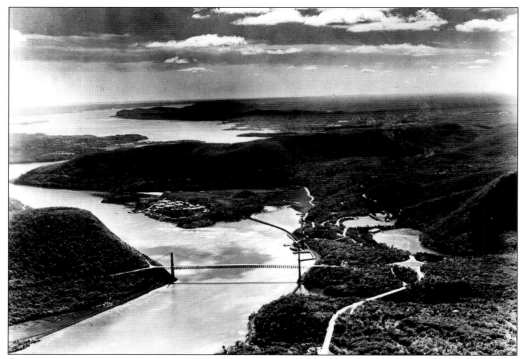

SCENIC VIEW. Looking south, this aerial view shows the Hudson River as it winds toward New York Harbor and the sea. Bear Mountain is at the right with Hessian Lake lying serenely at its base. Just south of the lake is the great playfield of Bear Mountain State Park. Iona Island is at center past the Bear Mountain Bridge and dock. Beyond Iona is Dunderberg Mountain. The east tower of the bridge is at the base of Anthony's Nose. (Palisades Interstate Park Commission.)

CONTENTS

ACKNOWLEDGMENTS

I dedicate this book to my parents, Mary Veronica and William Stuart Clark Jr., with memories of our family mystery rides from Paramus, New Jersey, that often resulted in a glorious day at Bear Mountain. There, with my sister, Jill, and my brothers, Skip and Peter, I spent pleasant days watching slender, young skiers defy gravity.

I gratefully acknowledge the help and support of my husband, Kevin, whose skills at editing and layout were indispensable. My daughters Veronica and Juliet, as always, offered their humor and encouragement.

Regarding my research, I begin by thanking Susan Smith, restoration and development director of the Palisades Interstate Park Commission (PIPC), for access to the archives and for checking and editing my manuscript. Edwin McGowan, director of science and the Trailside Museums, and archaeological steward Kelly Foxworthy provided assistance with archival materials. All images not otherwise attributed were loaned for publication by the PIPC.

I have been blessed by the generosity of James Donnery, Peter Carroll, John and June Gunza, Mary Therese Hansen, Albert Schaut, and Georgia "Sissy" Wallace for use of images from their extraordinary private collections. Special thanks go to Suzanne Brahm and the staff of the Highland Falls Library; Suzanne Christoff and Elaine McConnell and the staff of the Special Collections and Archives Division of the United States Military Academy (USMA) library; and Mark Langill, historian of the Los Angeles Dodgers. The News of the Highlands was a valuable resource while writing this book.

I am indebted to the following individuals who generously shared memories, information, and images with me: Doc Bayne, Joyce Evans, Frank Fey Sr., Edwina and Robert Gee, James and Helen Hannigan, William Hannigan, Gregory Jones, Joseph Klapkowski, Doris and Garry Lent, Roddy and Deb MacLeod, Mary Ellen Olivia, August Reberholt, Bob Rose, Jill and Edward Rose, Col. Gregory Stewart of the New York State Park Police, Violet Rosner, Erling and Dorothy Sandstrom, Robert Scott, Hans Strand Jr., Max Stroppel, PIPC chief forest ranger Timothy Sullivan, Mary Sutherland, Elizabeth "Perk" Stalter, James Wallace, and foreman Richard Vacek of Bear Mountain Bridge and the New York State Bridge Authority (NYSBA).

Finally I wish to acknowledge the farsighted women and men—past, present, and future—responsible for preserving the natural beauty and cultural significance of our beautiful Highlands.

Ronnie Clark Coffey
October 1, 2007

INTRODUCTION

Even Rudyard Kipling was distressed. The renowned British poet, visiting New York in the 1890s, heard the thunderous blasts and wrote, "We hear afar the sounds of war, / As rocks they rend and shiver; / They blast and mine and rudely scar / The pleasant banks of the river."

Across the Hudson River from the city, quarrying companies were dynamiting the majestic vertical cliffs of New Jersey's Palisades to provide crushed stone for the roadbeds of the growing metropolis. Acres of the magnificent rock walls had already been destroyed. In 1896, however, the beginning of a rescue came in the form of the Englewood Women's Club of New Jersey. A small group of civic minded, environmentally concerned, tenacious ladies began a movement that eventually included powerful politicians and wealthy philanthropists from both states. It led to the creation of the Palisades Interstate Park Commission (PIPC), and the list of members, donors, and interested parties grew to include names such as Rockefeller, Morgan, Vanderbilt, Phipps, Sage, Macy, and Gould along with governors, congressmen, senators, and future U.S. presidents. Its mission statement, "To preserve land and to provide opportunities for outdoor recreation accessible to all," reflected a spirit of enlightened conservation and public stewardship.

After laying the legal groundwork and raising the money to begin saving the Palisades, the young park management organization, led by commission president George W. Perkins Sr., expanded its mission into the Hudson Highlands. Time was running out there as well. On the border of Rockland and Orange Counties there was a different kind of development that caused considerable anxiety in the area. As noted in the article from the *News of the Highlands*, on July 31, 1909, "Two prisoners, at work on the site of the new Sing Sing Prison, below Fort Montgomery, made their escape last Saturday afternoon. They got away at 2 o'clock and in less than two hours they were recaptured." That same year, the November 13 edition carried a headline announcing, "Six escape from new prison grounds!" The placement of a prison stockade at Bear Mountain in 1908 with plans of relocating the Sing Sing Prison there was becoming a reality. Over 100 prisoners had begun clearing land, laying sewer pipes, and constructing buildings. Work projects for future prisoners included clearing the forests and quarrying rock.

Among those most interested in the ramifications of the prison project was the family of Edward Henry Harriman, a railroad magnate, who owned thousands of acres adjacent to the Bear Mountain tract. His concern over the seemingly inevitable destruction of the Highlands led him to privately purchase land in order to protect it. He proposed to donate thousands of acres of his estate and $1 million to the PIPC on the condition that the State of New York discontinue work on the prison and provide money for expansion of the park to be matched by private donors. Although Harriman died in 1909, his wife, Mary, and son William Averell carried out

his wishes; and so, in October 1910, the Harriman donation became Harriman State Park and the state gave jurisdiction of the former prison site to the PIPC to become Bear Mountain State Park. These adjacent parks were soon be linked, physically, by a beautiful highway called Seven Lakes Drive and, philosophically, by a similar mission of wilderness preservation and enjoyment. They are even frequently called by the single name, Bear Mountain-Harriman State Park. The focus of this book is Bear Mountain.

Work began immediately to prepare the land for a park. A dock was built to accommodate steamboat traffic. Underbrush and dead wood were cleared to make a path around Hessian Lake. A great playing field, 130 feet above the level of the river, was evened out and connected to the dock by a road. By 1913, a shelter had been added to the dock along with a pedestrian passageway under the West Shore Railroad tracks near the brand-new railroad station. Trails were created on top of Bear Mountain. Comfort stations, drinking fountains, a refreshment shelter, rowboat facilities, tennis courts, and ball fields were added for the benefit of visitors. Over the next few years, the forest, ragged and depleted from over cutting, was replenished by hundreds of thousands of seedlings.

During the summer of 1913, regular steamboat service started from New York City, and 22,590 passengers were carried to Bear Mountain for day trips and for camping around Hessian Lake. By 1914, it was clear that Bear Mountain was becoming one of the most popular recreation areas in the state. Construction began on the Bear Mountain Inn that included a restaurant, a cafeteria, overnight accommodations, a bakery, a laundry, and a soda bottling facility. Roads to the park were widened, literally paving the way for the growth of motor travel to the park.

The PIPC provided an interesting schedule of activities for summer visitors that included ball games, boating, and contests on the playfield. To the delight of park patrons, the commissioners decided to add an array of winter sports, making the park a year-round destination. During the winter of 1922–1923, visitors could experience tobogganing, skiing, snowshoeing, and ice-skating. In succeeding seasons, a skating pavilion was the scene of exciting hockey games and ice shows. Surpassing all other winter events, however, was world-class ski jumping, which thrilled generations of athletes and spectators.

The commission's vision of recreation soon expanded to include nature education. This led to the creation of the Trailside Museums and Zoo, a satellite of the American Museum of Natural History. Its network of creatively marked nature and history trails, the first of their kind in the nation, was studied and copied by other parks around the country. The first section of the Appalachian Trail was built at Bear Mountain and passed through the Trailside area.

During the Great Depression, the PIPC, in concert with the steamboat companies, made prices low to keep the park accessible. In 1941, a new manager was hired for the inn. For the next 25 years, John Martin left the stamp of his vibrant personality and creative administrative skills on the park. An avid sports fan, Martin invited a variety of sports teams to Bear Mountain to train. Visitors came in droves to watch the Brooklyn Dodgers, the New York Giants, Olympic boxing hopefuls, and other athletes during their practices. After World War II, the playgrounds saw a new generation of children delight in all the park had to offer. Change occurred elsewhere in the park as well. In the interest of preservation, the commission had certain powers to exercise eminent domain to acquire private property. The continued growth of the park system led to the acquisition of several mountain villages whose loss is still mourned by locals. One of these was Doodletown, a historic village at Bear Mountain.

Through the years, budget cuts and other factors have eliminated some activities; the most missed, perhaps, being ski jumping. Bear Mountain State Park, however, continues to be a haven for those in search of the natural loveliness of mountains and lakes. The PIPC continues its commitment to save magnificent parkland for future generations. In his poem "The Heritage," Arthur Abbott expressed, "For beauteous land redeemed has been / From commerce's grasping fee, / A heritage through coming years / And joy to you and me."

One

HISTORIC GROUND

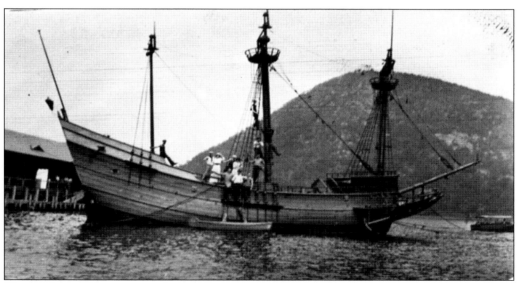

HALF MOON. Tourists posed aboard a replica of Henry Hudson's ship *Half Moon* at Bear Mountain dock in 1915. Built for the Hudson-Fulton Celebration in 1909, it commemorated the exploration of the river in 1609. Along his journey, the explorer encountered Native Americans whose ancestral presence in the valley dated back over 5,000 years. Soon other Europeans came, displacing the native inhabitants and altering the environment by lumbering, farming, and mining. (Smith-Burley collection.)

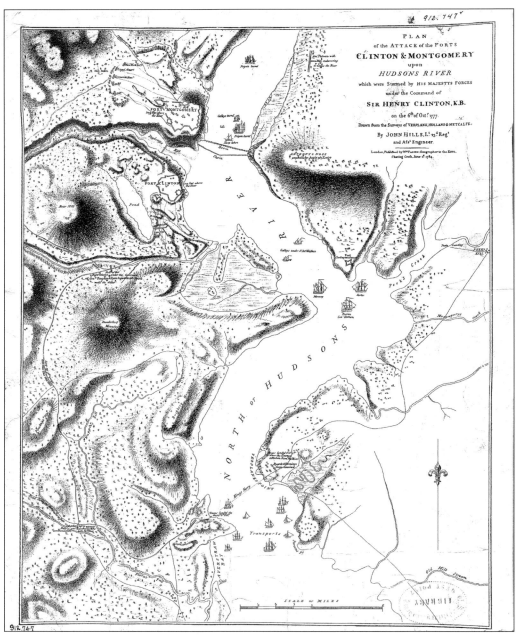

MAP OF BRITISH ATTACK. At the dawn of the American Revolution, the Highlands were of tremendous military importance. The British intended to "divide and conquer." Commanded by Sir Henry Clinton, the army expected to separate the northern colonies from the southern by controlling communication and transportation on and across the Hudson River. The American plan was to block passage of the British up the Hudson River. (United States Military Academy Library.)

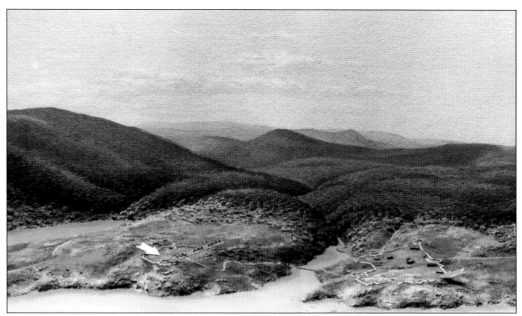

FORT CLINTON. On the advice of Gen. George Washington, the Continental Congress authorized forts to be built in the Hudson Highlands. Fort Clinton was built below Bear Hill, later called Bear Mountain, on the south side of Popolopen Creek. Fort Montgomery was built on the north side with a bridge connecting the two forts. As part of the fortifications, an iron chain was stretched across the Hudson River from Fort Montgomery to Anthony's Nose on the opposite shore. The diorama pictured above depicts the outlines of the twin forts and indicates the location of the current Trailside Museums at Bear Mountain. Below is an artist's rendering of the outer redoubt of Fort Clinton, which can still be seen.

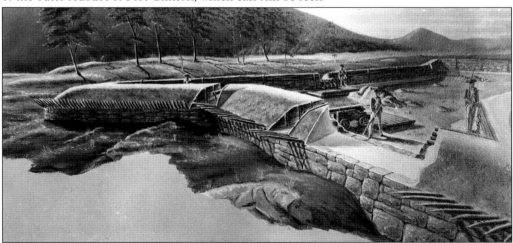

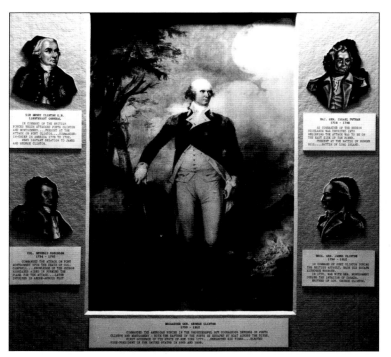

GEORGE CLINTON. Ironically three of the principal officers involved in the Highlands and one of the forts were all named Clinton. Brig. Gen. George Clinton (center), who was also governor of New York, had command of the two American forts. His brother, Brig. Gen. James Clinton (lower right) had charge of Fort Clinton. Their adversary Sir Henry Clinton (upper left) commanded the British forces.

THE MARCH. On October 6, 1777, more than 2,000 British troops, under command of Sir Henry, created a diversion near Peekskill, crossed the river, and marched overland from Caldwell's Landing near Stony Point. They arrived at Doodletown, a village in a valley south of Bear Mountain. Dividing into two groups, they marched around the mountains and attacked the landward defenses of Forts Clinton and Montgomery while the British navy bombarded from the river.

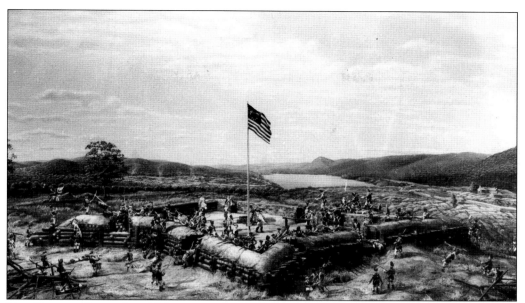

THE BATTLE. Fewer than 700 men combined to defend Forts Montgomery and Clinton. After a day of valiant fighting, the Americans were driven from the forts. Although the British claimed victory, the battle delayed the British advance up the Hudson River to join the forces of Gen. John Burgoyne. The time spent fighting, attending to the wounded, and burying the dead prevented Sir Henry's forces from reinforcing Burgoyne's, who were subsequently defeated at Saratoga, a major turning point of the war.

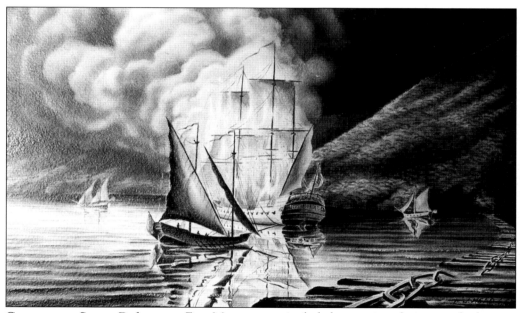

CHAIN AND SHIPS. Defenses at Fort Montgomery included a massive chain stretched across the river on log rafts to keep the British from sailing north. The Americans had positioned five ships to guard the chain. As the outcome of the battle became evident, the patriots burned their ships to prevent their capture. A witness described them as "pyramids of fire."

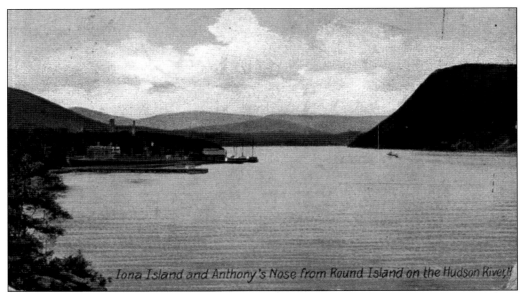

Iona Island and Anthony's Nose from Round Island on the Hudson River.

IONA ISLAND. Sold to colonists by the Haverstraw Indians, this 127-acre island near Bear Mountain was called Salisbury, Beveridge, and later, Weygant Island. It reportedly sheltered pirates who preyed on Hudson River shipping in the late 1600s. Above, a rare postcard looks north at Iona Island and Bear Mountain at left. In the mid-1800s, D. C. Grant purchased the island and planted fruit trees that thrived. His son-in-law Robert Hasbrouk planted vineyards of Iona grapes from which the island derives its current name. Iona grapes and wine were advertised in contemporary New York City magazines. Hasbrouk's white mansion, below right, became a hotel under subsequent owners in 1890. A recreation area was created, offering picnic grounds, a pavilion, a baseball field, a merry-go-round, and a Ferris wheel, which were popular with visitors. The steamer *Pioneer* ferried day-trippers from Peekskill to Iona for 10¢. (Above, Coffey collection; below, Schaut collection.)

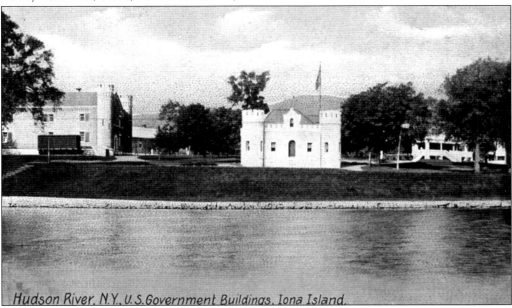

Hudson River, N.Y. U.S. Government Buildings, Iona Island.

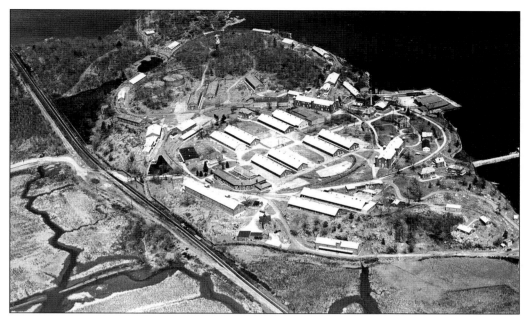

WAR AND PEACE. In 1899, the navy bought Iona Island to use as a base for assembling and storing munitions. During World War I, the principal activity for the 200 employees was the preparation of powder charges for shells on battleships. The dangerous cargo was off-loaded at Iona and transported to storerooms on trains powered by sparkless compressed-air locomotives. The railroad, known as the Confined Destruction Line, was only a few miles long. Also on the island were a fire department, a hospital, an electric plant, waterworks, and a telephone system. By 1943, over 800 people, including resident navy personnel, worked at the complex of 146 buildings seen above. After World War II, the base was disbanded. Since 1965, the island has been part of the Palisades Interstate Parks, protected as the tidal marsh and avian sanctuary seen below.

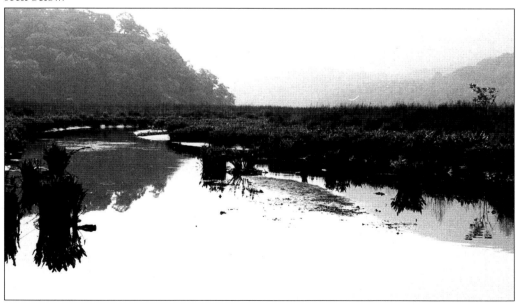

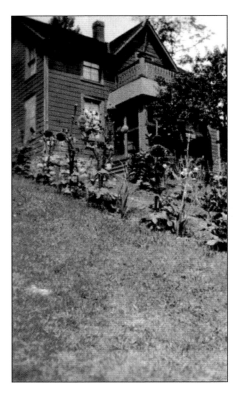

DOODLETOWN. The charming Steinman home, seen at left, was situated in Doodletown, one of the early settlements in the Highlands. Doodletown occupied a peaceful valley surrounded by Bear, West, and Dunderberg Mountains. Research suggests it derived its name from the Dutch words *dood dell* meaning "dead valley," a possible reference to a profusion of dead timber. By 1776, the hamlet consisted of about 20 log cabins. Between the mid-1800s and mid-1900s, Doodletown was home to about 35 families along with summer residents. Below, the Montville Community Church, built on the property of Caleb June in 1889, was Doodletown's second church. It served the self-reliant population of townspeople for over 60 years. After 1910, the private homesteads were gradually acquired by the PIPC to enlarge Bear Mountain State Park. (Above, Gee collection; below, PIPC Archives.)

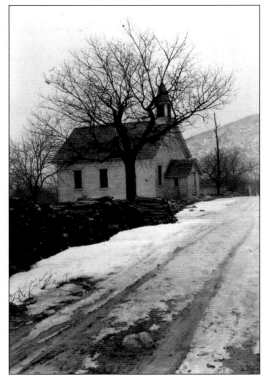

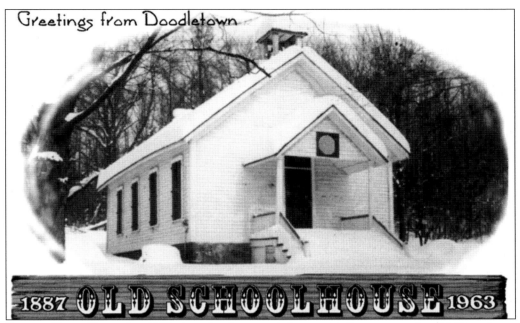

Greetings from Doodletown

1887 OLD SCHOOLHOUSE 1963

SCHOOL DAYS. Erected in 1887, the school pictured above initially accommodated 140 students. Construction of the school and the two outhouses behind it cost $1,500. In 1926, a larger school was built, and the old schoolhouse served as a community hall where square dances, parties, and other events were held. (Wallace collection.)

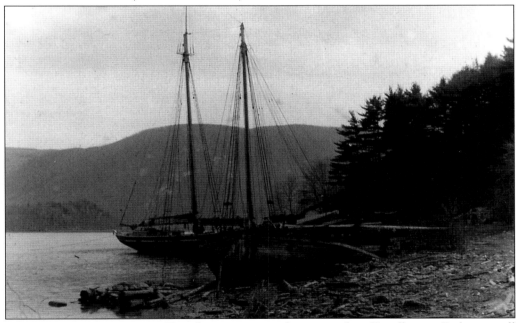

DOODLETOWN BIGHT, 1908. Two sloops are moored temporarily at Doodletown Bight, a small bay and stream outlet on the Hudson River east of the village near Iona Island. Beside them are piles of cordwood ready for shipment. During the 1800s and early 1900s, woodcutters of Doodletown provided fuel for the brickworks of Haverstraw and the area's iron furnaces.

CROSSROADS. The intersection of Doodletown Road and Pleasant Valley Road (foreground) is pictured as it was in the 1950s in this drawing by former Doodletown resident Elizabeth "Perk" Stalter. From left to right are the Siegel home in partial view, the stone facade of the school, the Herbert home and field, and the Montville Community church. At right is the Lady Powell home, also known as the Clubhouse. (Stalter collection.)

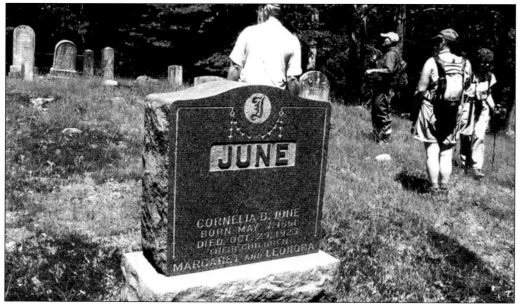

CEMETERY. Hiker Edward Rose searches at the June family cemetery for the name of a distant relative. The 100-square-foot burial ground with stones dating back to 1840 lies on a wooded slope off Doodletown Road. Around the cemetery, nature reclaims the land that was once a thriving community. Crumbling foundations, moss-covered steps, untrimmed rose bushes, and paths that were once roads combine to evoke a time past. (Coffey collection.)

Two

A PARK IS BORN

SING SING. In 1908, New York State began the relocation of Sing Sing Prison from Ossining to Bear Mountain. This enclosure housed prisoners who had begun construction of a larger facility. Concern over the proximity of a prison and the destruction of scenery caused a public outcry. The Harriman family donated 10,000 acres of adjacent land and $1 million on condition that the state make Bear Mountain into a park. The planned prison was abandoned. The playfield occupies this area today.

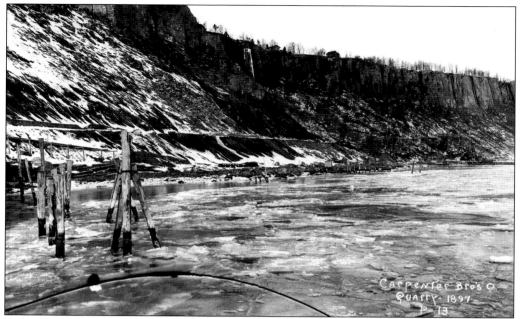

PALISADE QUARRY. In the late 19th century, the majestic cliffs of the Palisades along the Hudson River were being blasted away to provide building stone for New York City. Quarrying operations such as the Carpenter Brothers site in Fort Lee, New Jersey, pictured here in 1897, were slowly destroying the spectacular natural beauty. Blasting operations were moving north into Rockland County. A vehement campaign led by the New Jersey State Federation of Women's Clubs prompted legislation in New Jersey and New York, resulting in the creation of the Palisades Interstate Park Commission (PIPC), which was given power to acquire land and preserve scenery. Using public funds and private donations, the State of New York and the PIPC began the slow process to save the Palisades.

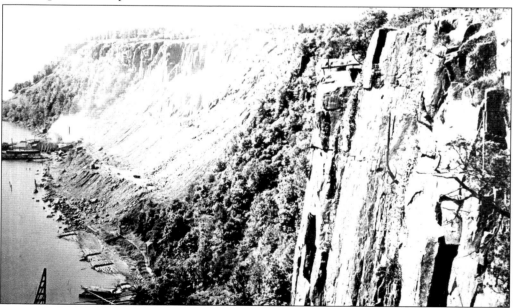

WOMEN'S CLUB. Hosted by yacht owner Harrison B. Moore (center), members of the Englewood Women's Club organized a junket in 1897 to inform press and politicians about the destruction of the Palisades. This local women's group galvanized support for legislation to protect the disappearing grandeur of the Hudson Valley. Their activism in this cause is made more remarkable by the fact that women did not have the right to vote for 23 more years.

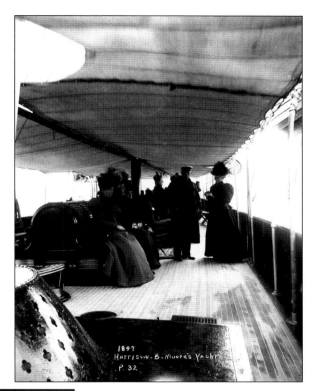

EDWARD PARTRIDGE. In November 1907, Dr. Edward Lasell Partridge, an early conservation advocate, wrote an article for the *Outlook* magazine on the preservation of the Highlands, proposing that the area be declared a national park. His visionary plan included nature education and scenic drives. Partridge, a Hudson Highlands resident and friend of the Harrimans, became a commissioner of the PIPC in 1913, serving until 1929.

HARRIMAN FAMILY. Owners of a 30,000-acre estate in the west Hudson Highlands, Mary and Edward Harriman (left) wanted to preserve the mountains from exploitation. After her husband's death in September 1909, Mary's concern over the construction of Sing Sing Prison at neighboring Bear Mountain grew. She agreed to give the state of New York 10,000 acres of land for a state park and $1 million in cash to administer it, if the state ceased work on the prison and contributed $2.5 million to purchase more land. On October 29, 1910, with funding in place, 19-year-old William Averell Harriman (below) presented to the PIPC 10,000 acres of land and $1 million. Harriman remained a commissioner and later served as governor of New York. (George Grantham Bain Collection, Library of Congress.)

GEORGE W. PERKINS SR., 1862–1920.
George Walbridge Perkins Sr. rose from a modest background to become a powerful businessman and conservationist. Business interests led to a meeting with Gov. Theodore Roosevelt in 1900. Impressed by Perkins, Roosevelt invited him to serve as president of the newly formed PIPC. During his 20-year tenure, Perkins was the guiding force in developing the Palisades Park system, negotiating land purchases, raising funds, and overseeing services.

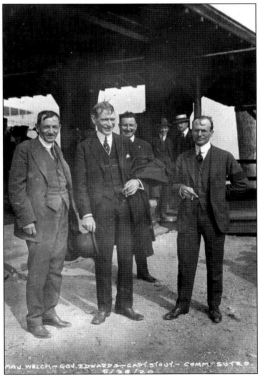

MAJOR WELCH. At the Bear Mountain dock in 1920, from left to right, are Maj. William A. Welch, New Jersey governor Edward Edwards, Hudson River Day Line captain Stout, and PIPC commissioner Frederick Sutro. Welch served the PIPC as general manager and chief landscape engineer for 40 years. The work he accomplished was termed "revolutionary and evolutionary," planning and overseeing the infrastructure to support millions of visitors. Welch also served as advisor to the National Park System and park systems worldwide. Lake Welch was named in his honor.

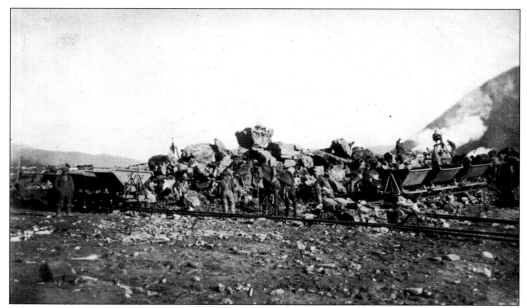

CONSTRUCTION BEGINS. Development of Bear Mountain State Park began in 1910 when the PIPC took possession of the abandoned prison site. Here workers remove boulders to begin the process of leveling the great playing field. The location was ideal except for its inaccessibility. The lake and playfield were 130 feet above the river. There were no entrances or exits from the local highway nor were there roads between Bear Mountain and Harriman Parks.

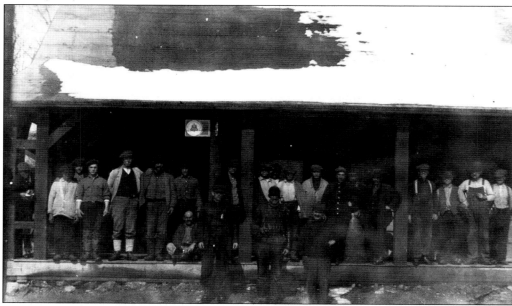

PAY DAY, 1914. Employees lined up to collect their wages under a recently completed shelter in March 1914. Many workers came by train from New York City and were paid $2 per day. Development of the state park required considerable labor. Paths were cleared for strolling and hiking, visitor buildings were constructed, and roads were built. Other projects included making tent platforms, picnic tables, benches, boats, and swings.

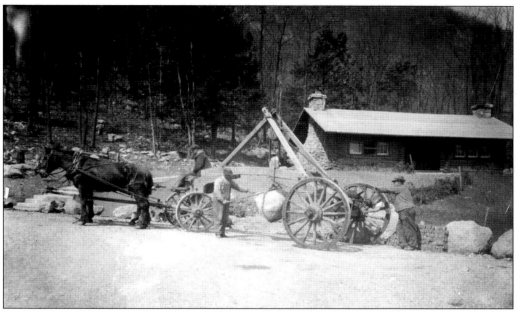

POLICE STATION, 1914. Using a specially rigged cart equipped with a winch, workers relocate a boulder to a spot near the first police station at Bear Mountain. The building was situated at the Horseshoe Turn, a U-shaped road at the southwest corner of the playfield near the site of the present ice rink.

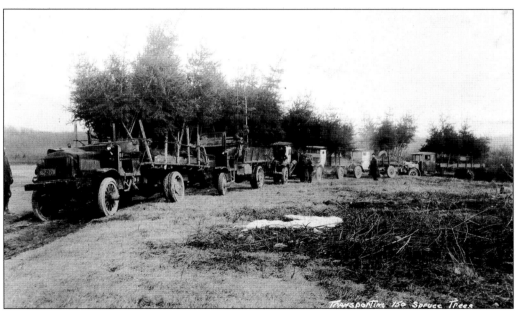

TREE PLANTING. Trucks carried 150 spruce trees through the park in March 1928. Tree planting was a significant aspect of the work done in the early years. The forests of Bear, West, and Dunderberg Mountains had been cut over for more than 50 years, first for lumber, then for charcoal for local iron furnaces, and lastly for cordwood to fire local brickyard ovens. Seedlings and more mature trees were planted to replenish the forests.

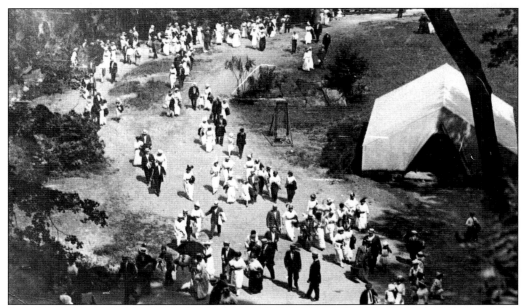

PARK OUTING. Anticipating a lovely day in the country, a boatload of city folk arrived at Bear Mountain in 1915. The steamboat ride on the *Highlander* from Manhattan had cost 50¢ per person. Two large tents served to shelter visitors at the lower playground. A short walk up the hill from the dock, the paths, picnic groves, boats, and great playfield waited to delight the ever-growing numbers of eager nature seekers.

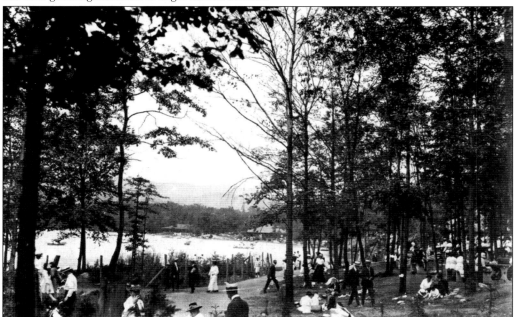

LAKE STROLL. A leisurely stroll around Hessian Lake was an ideal way to spend an afternoon in the 1920s, just as it is today. Meandering the stone lined, dirt path along the shoreline, these visitors were realizing one of the PIPC's visions, "To revive our hopes and to return us home again, renewed in spirit, strengthened in body, enriched in mind."

SHELTERS. Providing various shelters for the comfort and safety of visitors was a primary concern of the park commission. The photograph above shows a refreshment shelter (left) in 1914, consisting of a lunchroom and restaurant. The restaurant was quite a success. The annual PIPC report for the 1914 season states, "Of the thousands of patrons . . . not one complained." At right is a second open-air shelter with seating. Paths were graded from these buildings to the rowboat dock at the southwest end of Hessian Lake. Some material for early buildings had been salvaged from the old prison barracks. As the popularity of the park grew, construction could hardly keep pace with demand. Below, visitors in 1918 wait expectantly in front of a partially completed structure for motor coaches that shuttled them from the dock to the playfield up the hill.

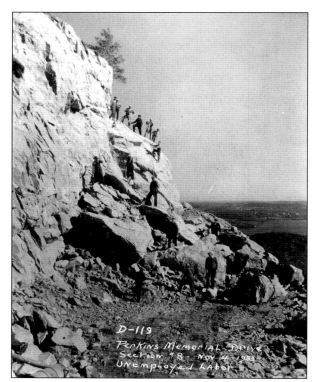

PERKINS DRIVE. For many years the commissioners had hoped to build a scenic drive to the top of Bear Mountain in memory of George W. Perkins Sr., president of the PIPC from 1900 to 1920. His generosity, devotion, and hard work were instrumental in creating the park. In 1932, in cooperation with the Civil Works Administration, work began. These two photographs show relief workers from New York City, Orange County, and Rockland County splitting rocks for the roadbed by hand using the plug and feather method. Holes were drilled into the boulders a few feet apart. Two narrow steel wedges called feathers were inserted into the holes. Between the feathers, a thicker bar called a plug was placed. The force of a sledgehammer on the plug caused the rocks to break apart. Ninety-five percent of the work on the roadway was done by manual labor.

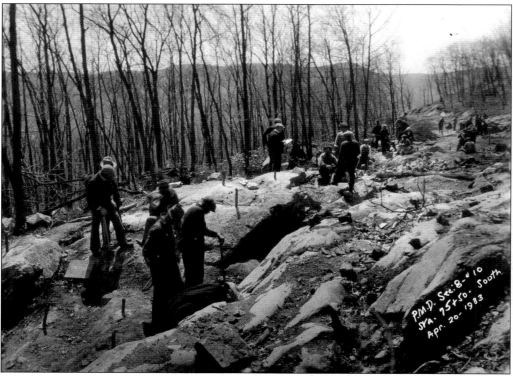

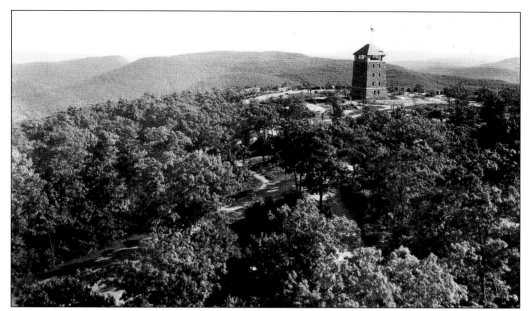

MEMORIAL TOWER. Perkins Memorial Tower, a gift of the Perkins family, is shown atop Bear Mountain. It bears an inscription dedicated to Perkins "whose broad vision and tireless energy made possible the preservation of the Palisades and the establishment of this great playground for humanity." Completed in 1934, the impressive mountain drive and striking tower were dedicated by Pres. Franklin Delano Roosevelt. The tower is now a museum and observation platform.

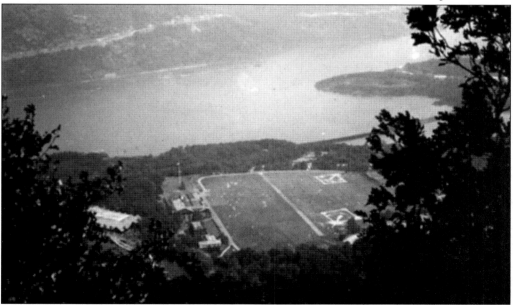

MEMORIAL DAY, 1939. Once established, Bear Mountain State Park continued to expand its services. Soon an inn, an administration building, camps, garages, and museums joined the original dock, boathouse, and food stands. During the 1930s and 1940s, open-air pavilions were added to house bumper cars, Skee-Ball, the Swiss Navy, Skooters, and the children's playground. At left in this aerial view is the large indoor skating rink. (Fey collection.)

WILLIAM T. HOWELL. From left to right, William T. Howell and friends George Peck, Moses Ely, and Clair Fairbanks make preparations for Easter dinner atop Bear Mountain in 1910. Howell was a hiker, photographer, author, nature lover, and writer who lived in Newburgh. He documents this Easter adventure and years of hikes and rambles in his detailed journal *The Hudson Highlands*. Through his enthusiastic accounts, one views the plants and animals of the area and the disappearing way of life of the farmers and woodcutters.

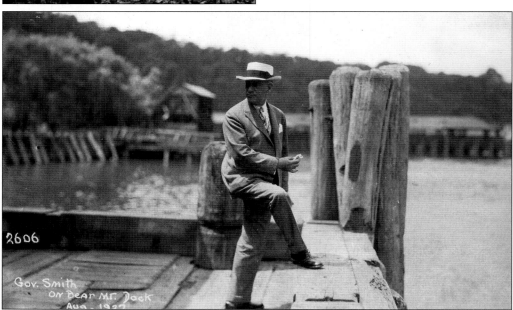

GOV. ALFRED E. SMITH. The PIPC existed in cooperation with the governments of New Jersey and New York and thus fell within the sphere of influence of governors and legislators from both states. Gov. Alfred E. Smith of New York stands on Bear Mountain Dock in August 1927. On that trip, he toured Bear Mountain and visited Boy Scout camps in Harriman State Park. (Hansen collection.)

Three

INN AND LAKE

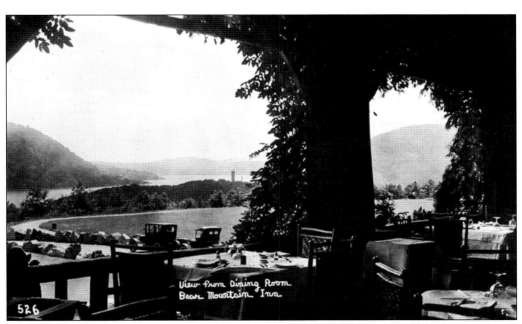

View from Dining Room.
Bear Mountain Inn.

526

BEAR MOUNTAIN INN. In 1914, under the direction of Bear Mountain's chief landscape engineer William A. Welch, construction was begun on a restaurant on the south side of Hessian Lake. Since its first year of operation, the Bear Mountain Inn has been the centerpiece of the park commission. Designed by the prominent New York City architectural firm of Tooker and Marsh, the inn had open-air balconies overlooking the lake and playfield. The view from the dining room above looks southeast toward Iona Island.

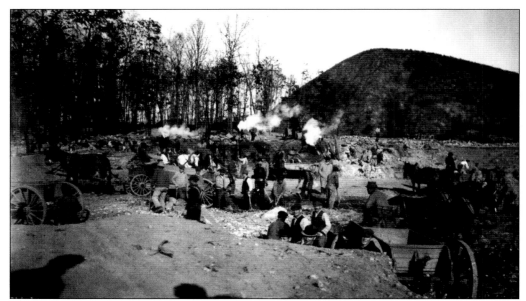

BUILDING THE INN. Actual construction began in 1914 with work done by park employees. Mule teams (above) haul boulders and debris as the foundation is dug. Axes, picks, sledgehammers, hand shovels, and steam shovels are in view. To avoid delays, the three-story inn was built using privately donated funds. Commission president George W. Perkins Sr. was the major donor. Work progressed rapidly under the watchful eye of William A. Welch. The 75,000-square-foot inn opened for business on June 3, 1915. The great stone arches of the first floor were made from moss-covered boulders from the old stone walls on park grounds. On the second floor, the peeled trunks of chestnut trees supported the roof.

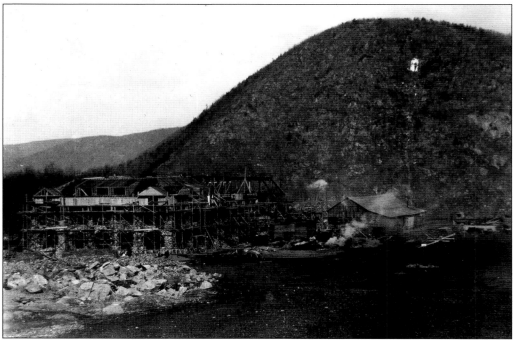

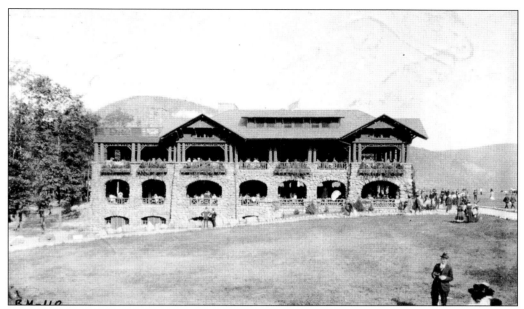

THE INN. An instant success, the restaurant accommodated 100,000 patrons during its first summer of operation in 1915. Perkins aptly described the Bear Mountain Inn as "a rugged heap of boulders and huge chestnut logs assembled by the hand of man, and yet following lines of such natural proportions as to resemble the eternal hills themselves." Located in the basement were state-of-the-art electric power, baking, laundry, and refrigeration facilities.

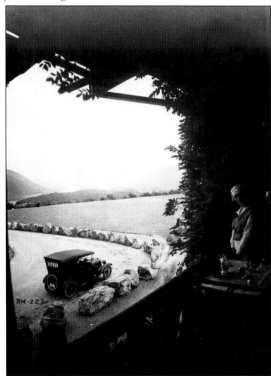

DINING ROOM. A charming waitress stands beside a table for two on the open-air porch on the second floor. On this floor were the main dining room, the à la carte restaurant, and a large kitchen. Afternoon tea was served from 3:00 to 6:00 p.m. On the third floor were store rooms and sleeping quarters for employees as well as a dining room for the restaurant help.

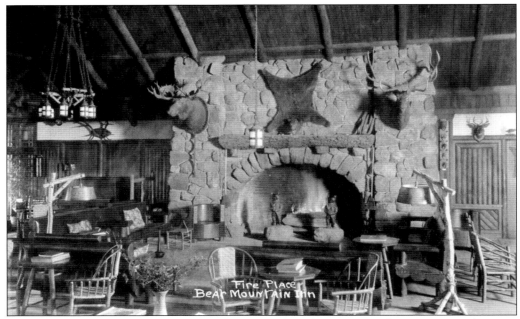

FIREPLACE, 1931. A favorite feature of the inn and rendezvous point for visitors was the great lounge with its massive stone fireplace in a rustic hunting lodge motif. On the right side of the mantle rests a large iron chain link, reputed to have been part of the first chain stretched across the Hudson River in 1777 between Fort Montgomery and Anthony's Nose.

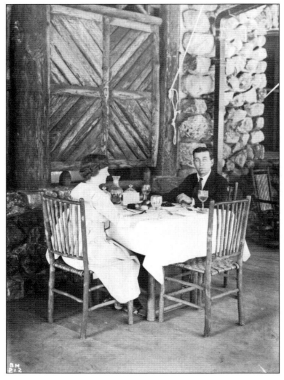

RUSTIC ELEGANCE. Surrounded by the dining room's log and stone decor, this couple anticipates a delicious meal at the inn. A message on a 1918 postcard stated, "We spent the day here. It is certainly one of God's own spots on earth. I believe it is the nearest to ideal of any place I have yet seen. We ate our dinner at this restaurant. Perfectly elegant."

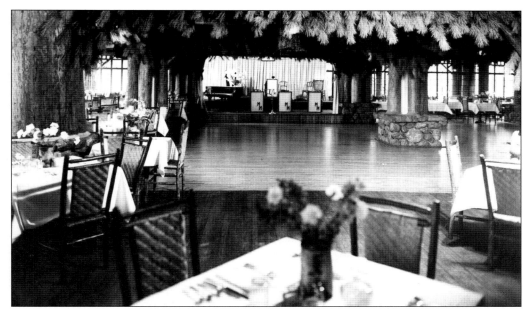

BANDSTAND. On a winter evening in 1933, the bandstand at the inn is set for the arrival of musicians and patrons. During the 1930s and 1940s, big bands came frequently to perform. Among the featured artists were Artie Shaw, Dell Courtney, Tommy Dorsey, Harry James, and Kate Smith. Smith composed her hit song "When the Moon Comes Over the Mountain" while sitting at a table at the inn.

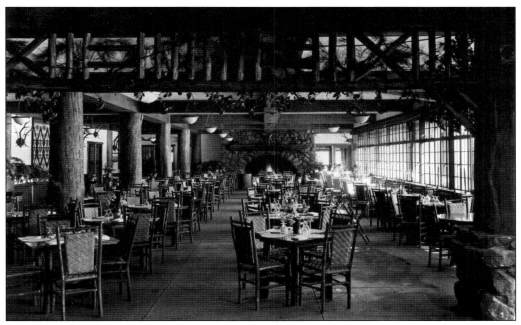

LUNCH PARTY. A single lunch party in the right rear corner of the dining room enjoys the warm glow from the fireplace. Large steel casement windows kept fall and winter diners comfortable while allowing for splendid views of the scenery and the activities on the great playfield.

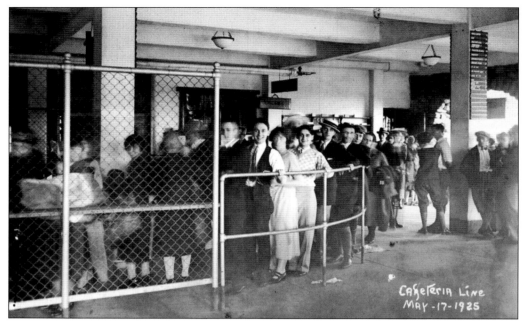

CAFETERIA, 1925. On the first floor of the inn, a cafeteria accommodated visitors who preferred faster, more economical service. On the posted menu in 1925, offerings included bread and butter, 5¢; soup, 15¢; roast beef and vegetables, 40¢; sandwiches and pie, 15¢; and frankfurters, 10¢. Coffee, tea, soda, and beer were available to drink.

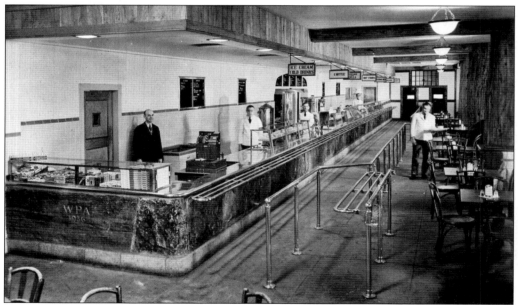

CAFETERIA, C. 1937. In their starched white jackets and dark ties, five cafeteria assistants pose with their manager before the arrival of the daily crowds. Renovated by Works Progress Administration (WPA) workers in 1936, the stone counter with its gleaming chrome and glass serving stations displayed the traditional menu items along with salads and ice cream. The flavored soda offered for sale was bottled in the inn's basement.

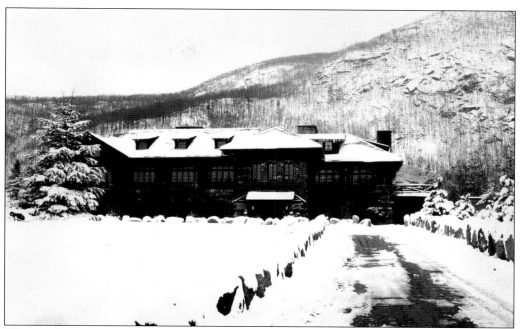

WINTER SEASON. Prior to 1922, the Bear Mountain Inn was only open in summer. For its first winter season in 1923, the inn was retrofitted to allow year-round use. Windows were added to enclose the open-air pavilion, and third-floor guest rooms were heated. (Hansen collection.)

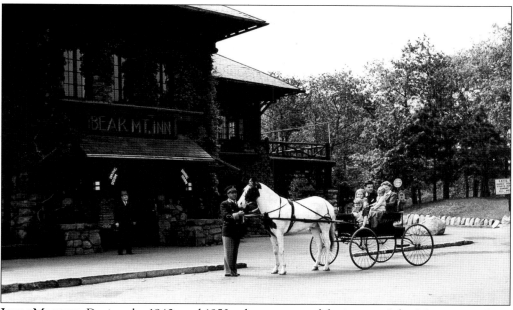

JOHN MARTIN. During the 1940s and 1950s, the manager of the inn was John Martin, seen here in 1942 with his family in a horse-drawn carriage at the entrance. Charismatic and energetic, Martin transformed the inn into a major destination by inviting professional sports teams to use the park for training and practice. The smartly dressed doorman wears a used uniform from the 1939 New York World's Fair, one of many acquired by the park for its employees.

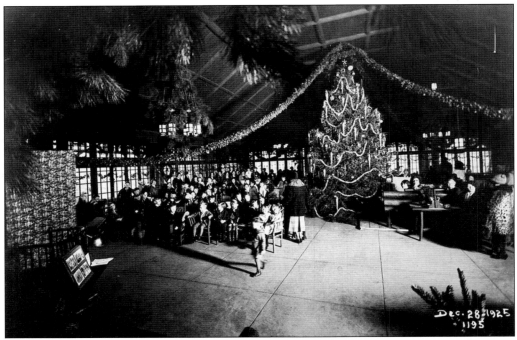

CHRISTMAS TIME. From its first year as a winter playground, Christmas was a special time at Bear Mountain. On December 28, 1925, this group of guests (above) admired the gaily decorated Christmas tree and bright light fixtures hung with pine boughs. Perhaps they later bought a postcard like the one pictured below showing the facade of the inn after a glorious snowfall. (Above, PIPC Archives; below, Wallace collection.)

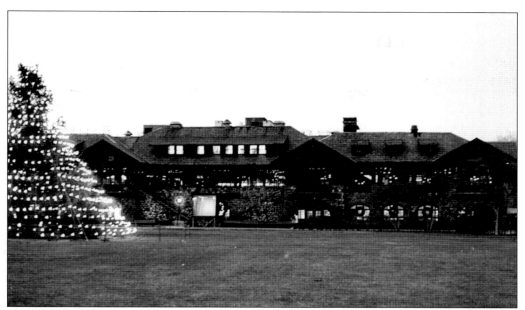

CHRISTMAS FESTIVAL. The happy tradition of the Bear Mountain Christmas festival began in 1970. It evolved into one of the park's most eagerly anticipated events. Held from December 2 to January 1, it was sponsored by the PIPC and the management of the Bear Mountain Inn. Opening night featured an outdoor tree-lighting ceremony, a Nativity scene, and a 40-foot lighted star at the crest of Bear Mountain. More than 20,000 lights made the trees around the playfield and picnic grove a sparkling wonderland. A dazzling fireworks display in the clear, cold night was the climax of the evening. The following day, Santa arrived. In the early 1970s, his sled was pulled by reindeer that were corralled in the southwest corner of the playfield. In the 1980s, Clydesdale horses had the honor of pulling the jolly old elf.

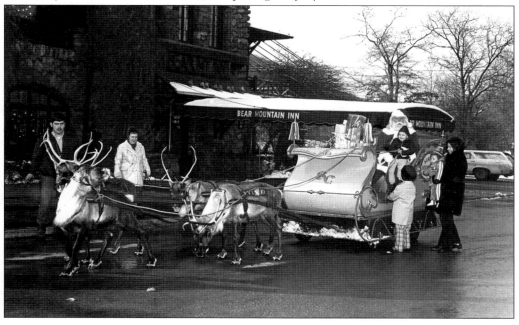

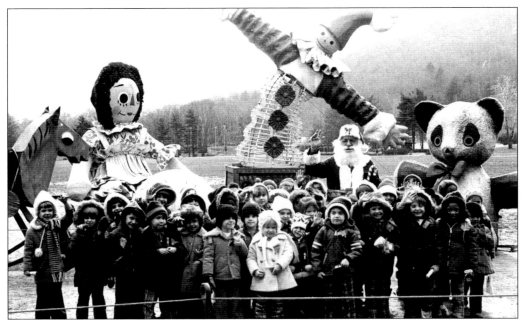

DECEMBER FUN. Much to the delight of the children, Santa was often accompanied by friends such as a horse, Raggedy Ann, Jack-in-the-Box, and a panda bear. During the 1980s, a salute to Chanukah was added to the winter festivities. Throughout the month of December, there was a full schedule of folk dancers, singing groups, bands, and occasionally a professional ice show.

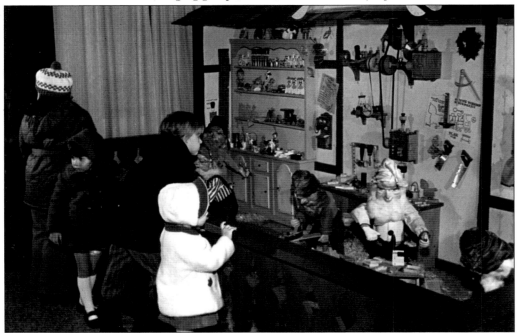

HOLIDAY DISPLAYS. Elaborate Christmas displays were set up on the ground floor of the inn. Doll houses, train layouts, card displays, and gingerbread houses made of candy canes, macaroni, and chocolate delighted the children of all ages who walked past them.

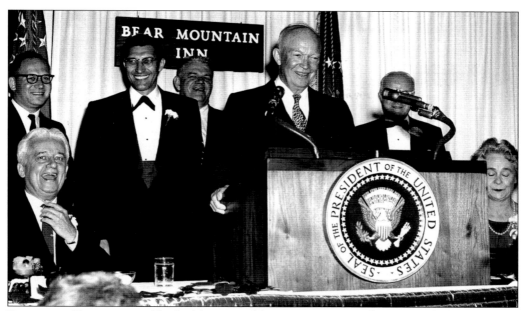

PRESIDENT EISENHOWER. Flanked by amused listeners, Pres. Dwight D. Eisenhower addresses some lighthearted remarks to fellow alumni and friends of the United States Military Academy's class of 1915 on June 4, 1960. Their 45th class reunion celebration was held in the main dining room of the Bear Mountain Inn. Standing at left behind Eisenhower is John Martin, the inn's manager. Seated at right is Congresswoman Katherine St. George. Others are unidentified.

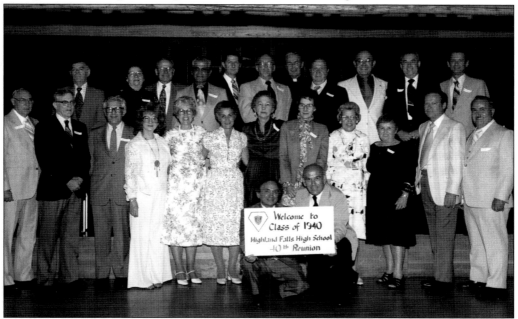

REUNION, 1980. Organizations and private individuals from the surrounding Orange and Rockland County towns frequently hold functions at the inn ranging from weddings to business meetings. Here the Highland Falls High School class of 1940 poses for a photograph at their 40th reunion. (William Hannigan collection.)

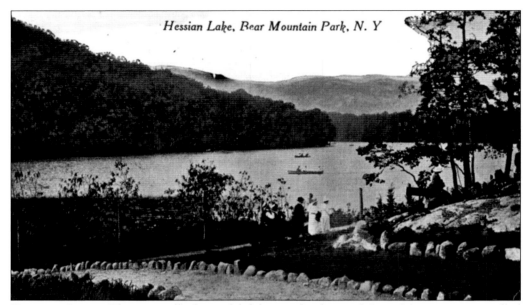

Hessian Lake, Bear Mountain Park, N. Y

HESSIAN LAKE. The naturally beautiful lake at the base of Bear Mountain was called Sinnipink by Native Americans, then Highland Lake, and finally Hessian Lake. Hessians were German-speaking mercenaries employed by the British during the Revolutionary War. After the battle at Fort Clinton in October 1777, there were reports that dead Hessian soldiers were thrown into the lake, giving rise to the name Hessian Lake. To the 1918 park visitor, a lake by any other name was but a sweet place to enjoy a stroll or a picnic. (Gunza collection.)

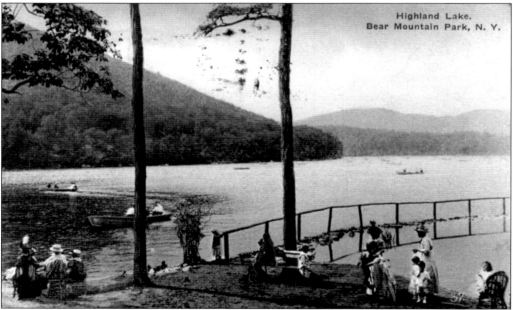

Highland Lake.
Bear Mountain Park, N. Y.

LAKESIDE, C. 1917. Shaded by a tall tree, several seated ladies relax by observing boaters on the lake. At lower right is a wading area for children formed within the lake by means of a wire fence and breakwater. White beach sand was laid over the bottom for the comfort of little toes. (Carroll collection.)

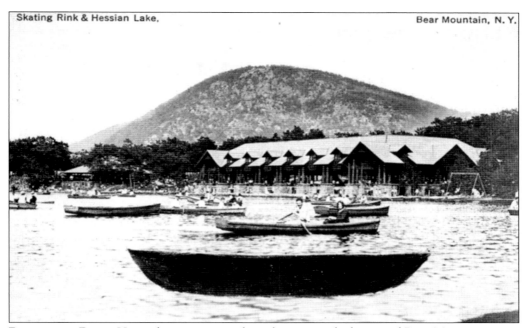

BOATS AND RINK. Happy boating parties have been a staple feature of Bear Mountain since 1913. This 1940 postcard shows a southeast view of the lake. The roller- and ice-skating rink pavilion burned down about 1941 and was replaced by an open-air facility. (Gunza collection.)

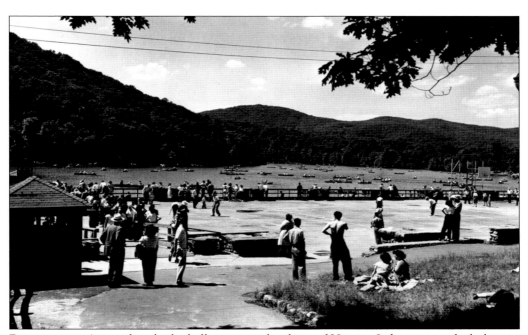

BASKETBALL. An outdoor basketball court on the shore of Hessian Lake was an ideal place to shoot hoops in 1948. Stone benches were provided for spectators, and a sidewalk around the perimeter allowed room for strolling, people watching, and enjoying the views of the mountain and the lake.

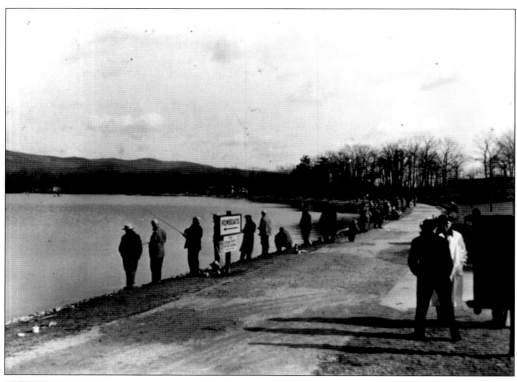

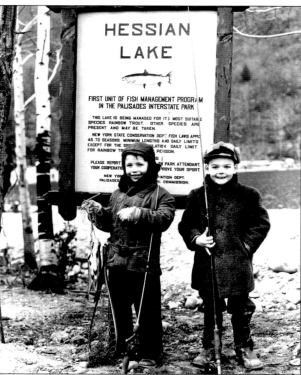

GONE FISHIN'. Fishermen (above) line up all along Hessian Lake on a cool April morning in 1938. Trout, sunfish, perch, bass, and pickerel were among 36 species identified within the park. Lakes were stocked to improve the fishermen's chances. Below, two happy youngsters proudly display the day's catch. Fish management guidelines provided by the New York Conservation Department are posted behind them. On this day in 1949, these little anglers would agree that fishing at Bear Mountain was "reel" fun.

CAMPERS, C. 1917. Silhouetted in the twinkling reflection off Hessian Lake, two young women enjoy a boating scene at sunset. Camps in the Palisades Interstate Park system were not only for children, but also for working adults who had to pass a rigorous background check. In surveys of female campers, occupations noted were store girl, saleswoman, factory worker, seamstress, domestic house worker, nurse, teacher, stenographer, bookkeeper, typist, secretary, laundress, telephone operator, and student.

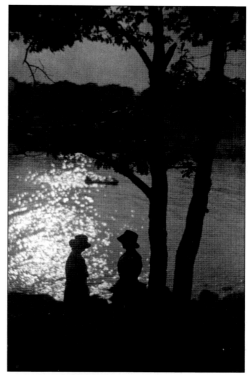

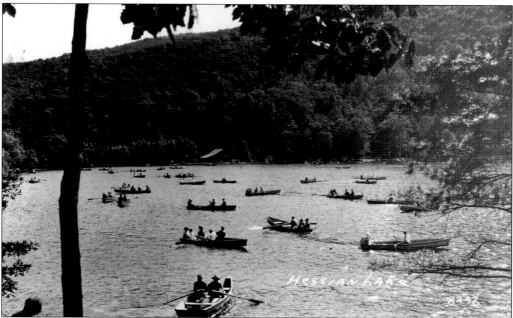

BOATING. Rowing a boat on Hessian Lake was one of the most popular activities from the first year of the park. By 1916, the PIPC had built over 100 boats but eventually had to limit boating time to 30 minutes with a 25¢ deposit to insure compliance with the rule. The rustic boathouse on the west side of the lake was built in 1914.

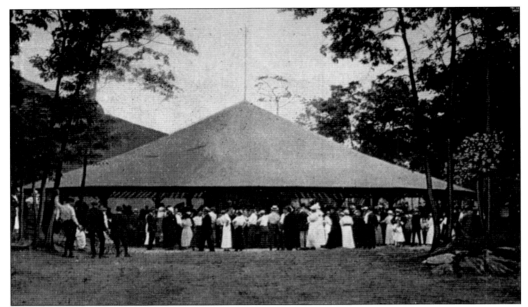

THE PAVILION. The sound of music joined the songs of birds and laughter of picnickers in 1915 with the construction of a dance pavilion on the eastern shore of Hessian Lake. Circular in shape and illuminated by electric lightbulbs, the dance floor measured 5,000 square feet with an elevated bandstand in the center. The pavilion began a tradition of dancing at Bear Mountain that continued throughout the 20th century. (Carroll collection.)

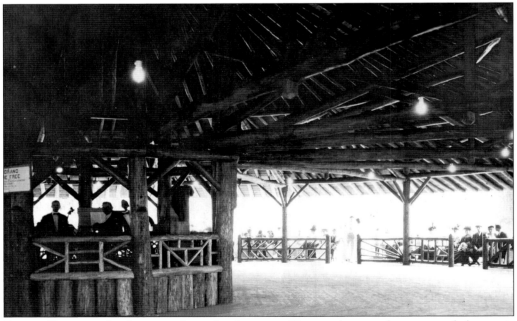

DANCE PAVILION. Looking out from the dance pavilion, a photographer captured the rustic charm of its architecture. A deadly blight had ravaged the park's magnificent chestnut trees, but their lumber was used in construction whenever possible. Note the lovely chestnut railing around the dance floor.

46

Four

THE BRIDGE

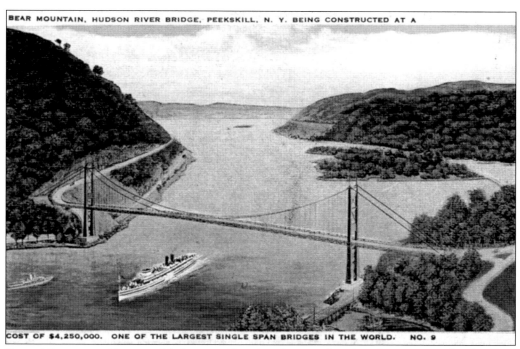

BEAR MOUNTAIN, HUDSON RIVER BRIDGE, PEEKSKILL, N. Y. BEING CONSTRUCTED AT A COST OF $4,250,000. ONE OF THE LARGEST SINGLE SPAN BRIDGES IN THE WORLD. NO. 9

BEAR MOUNTAIN BRIDGE. Under consideration for two decades, the contract for the Bear Mountain-Hudson River bridge was signed in March 1923. The span, with a projected cost of $4.25 million, was funded by a private company whose president was E. Roland Harriman. Since there was no Hudson River bridge south of Albany at this time, it was intended to provide a shorter route from the middle states to New England and to ease access to Bear Mountain State Park. (Carroll collection.)

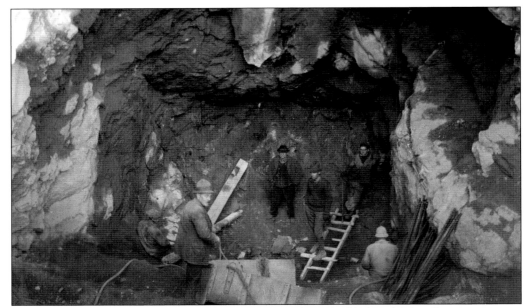

CABLE ANCHORAGES. The cable anchorages were to be imbedded in solid rock, so excavation of the chambers began with successive steps of blasting and digging by hand. The work was hot and tiring. On each side of the river, three boys were employed to bring water to the crews. Many of the 150 workmen lived on site in a bunkhouse. The four foremen had separate quarters. Engineers stayed in Fort Montgomery at the mountain inn. (NYSBA.)

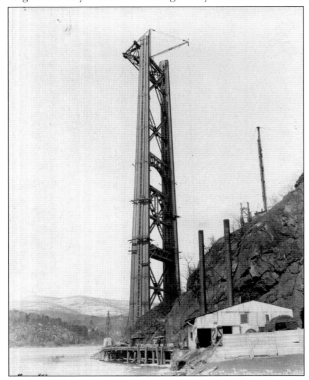

STEEL TOWERS. Once the pier foundations were in place, the 1,632-foot-high steel towers were erected in sections upon steel casting footings using the creeper derrick seen at the top. The weight of the 351-foot towers had to be distributed equally at their bases. Technically the bridge is classified as a parallel wire cable suspension type. (NYSBA.)

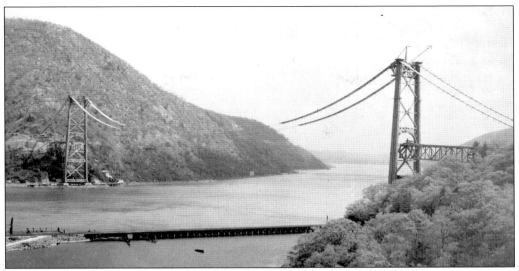

FOOTBRIDGES. After erection of the towers, steel wire ropes were strung across the river to support workmen's footbridges. These paths of wooden slats high above the river enabled workers to begin spinning and placing the suspension cables. Cleats were placed on the wooden floorboards to provide sure footing on the steep grades. The final contour of the suspension cables was exactly three feet above the footbridges. (Hansen collection.)

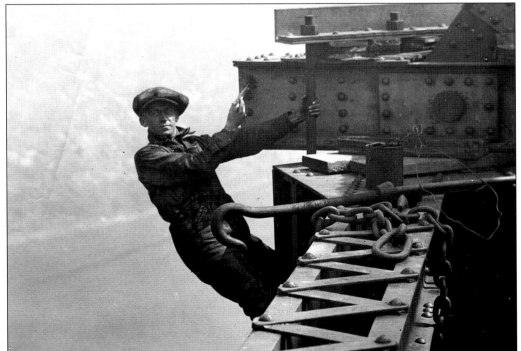

BRIDGE PAINTER, 1924. High above the Hudson River without a safety harness, a worker paints the rivets of the Bear Mountain Bridge superstructure. Great courage was required of the bridge men as they worked on the towers and the footbridges. Despite the lack of modern-day safety precautions, the bridge was completed without any loss of life. (Scott collection.)

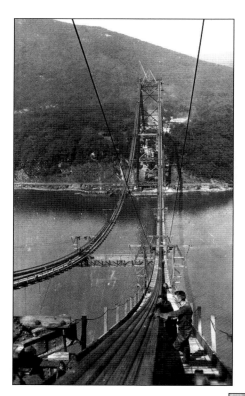

SPINNING WHEELS. Using pulley wheels, a single bridge wire was looped back and forth across the entire span of the river 98 times to create just one strand. Each of the two great cables was composed of 37 strands. Stringing the wires took three months. Here two workmen check six strands already spun. The bridge wire was manufactured by the Roebling Company, builders of the Brooklyn Bridge. (Hansen collection.)

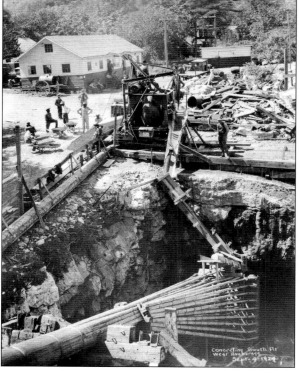

ATTACHING THE CABLE. Upon completion, the strands were compacted by a "squeezing gang" into a single round cable 18 inches in diameter. The cable was compressed at two-foot intervals and secured by a tight circle of galvanized annealed wire. Then the strands were spread in a footlike manner for attachment to eyebar chains that were cemented into the anchorage. Each strand transferred its part of the load to the solid, waterproof concrete and rock foundation. (NYSBA.)

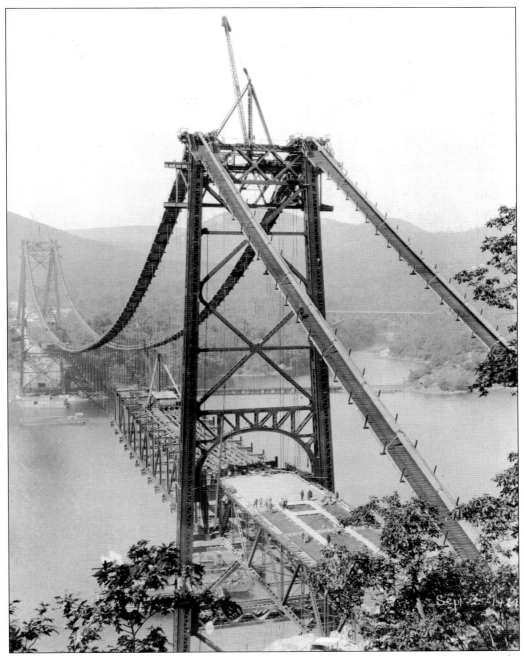

ROADBED. With cables completed and suspension ropes in place, the roadway began to take shape. Steel truss members were lifted from barges seen on the river below. The superstructure was erected simultaneously from the east and west towers to equalize the load on the cables and towers. To support the concrete roadway, a tight grid of metal reinforcement bars was installed across the bridge. (NYSBA.)

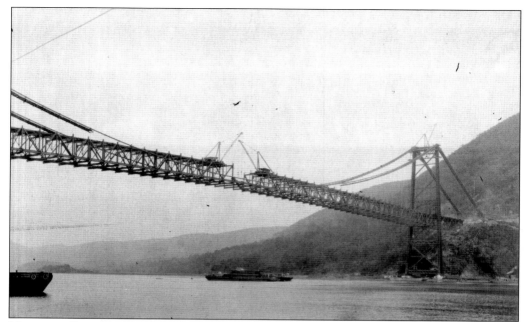

NEARING COMPLETION. Excitement increased as the bridge neared completion. With the connection of the bottom steel chord at the center, the east and west shores were joined. Upper chords were then set in place. The roadbed was at the level of the top chords, allowing an unobstructed scenic view up and down the river. (NYSBA.)

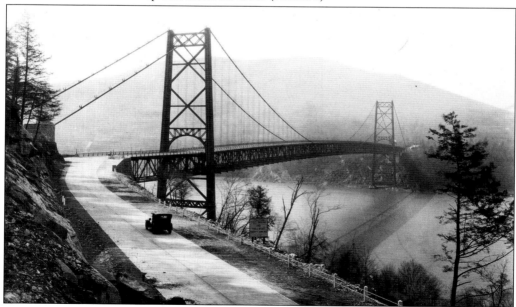

TEST OF TIME. The Bear Mountain Bridge remains a technical marvel. Deep in their anchorages, the cables have barely shifted over the years. Ships have a clearance of 155 feet at high tide, which has proven to be adequate for modern Hudson River shipping. As part of the Appalachian Trail, the bridge accommodates hikers as well as pedestrians and motorists. Locals know that it is the best place to view the park's annual Fourth of July fireworks. (Hansen collection.)

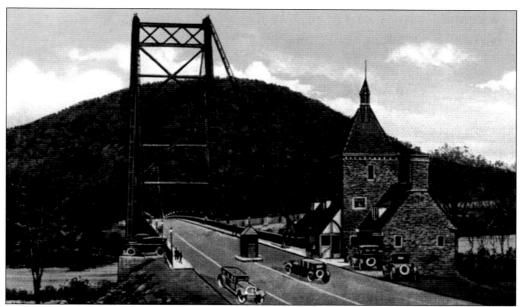

TOLLGATE. Completed in 20 months, the Bear Mountain-Hudson River bridge was one of the longest spans in the world devoted to automobile traffic. On Thanksgiving Day 1924, the West Point band led a motorcade across the bridge to a reviewing stand near this tollgate where Mary Harriman unveiled a plaque honoring "all who with thought, labor, and loyalty have contributed to the construction of this bridge." (Donnery collection.)

TOLL COLLECTORS. A tollhouse at the west approach collected tolls for vehicles, people, and animals. A car and driver cost 80¢. An additional adult passenger was 15¢. A child cost 10¢. Families occasionally hid children in the trunk to avoid their toll. A rider on a saddle horse paid 30¢. Considering that laborers made $2 per day, this was expensive. Another tollhouse collected revenue on the east side. (Hansen collection.)

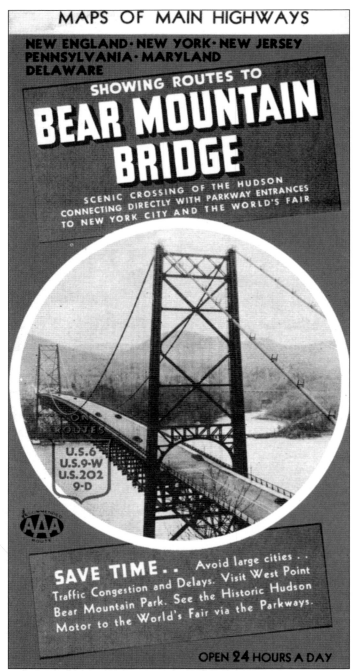

MAPS OF MAIN HIGHWAYS

NEW ENGLAND · NEW YORK · NEW JERSEY PENNSYLVANIA · MARYLAND DELAWARE

SHOWING ROUTES TO

BEAR MOUNTAIN BRIDGE

SCENIC CROSSING OF THE HUDSON
CONNECTING DIRECTLY WITH PARKWAY ENTRANCES
TO NEW YORK CITY AND THE WORLD'S FAIR

U.S.6
U.S.9-W
U.S.202
9-D

AAA

SAVE TIME . . Avoid large cities . .
Traffic Congestion and Delays. Visit West Point
Bear Mountain Park. See the Historic Hudson
Motor to the World's Fair via the Parkways.

OPEN 24 HOURS A DAY

MAP, 1939. This 1939 map of the region recommended the Bear Mountain Bridge for a "scenic crossing of the Hudson connecting directly to New York City and the World's Fair." To underscore the ease and accessibility of travel via the bridge, a table of mileages gave distances to Chicago, Cleveland, Washington, D.C., and Miami. Ironically, the bridge was not profitable. It was sold to the state in 1940 for $2,275,000. Tolls were reduced and usage of the bridge increased. (MacLeod collection.)

Five

TRANSPORTATION

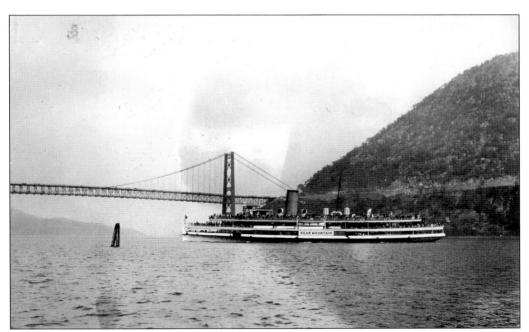

THE *BEAR MOUNTAIN*. Crowded with eager visitors, the *Bear Mountain* approaches its destination. Owned and operated by the Sutton Line, this side-wheeler was originally called the *Clermont* under prior ownership of the Catskill Evening Line. Capable of carrying 600 to 800 passengers, the *Bear Mountain* sailed daily from New York City from 1913 until 1948. (Hansen collection.)

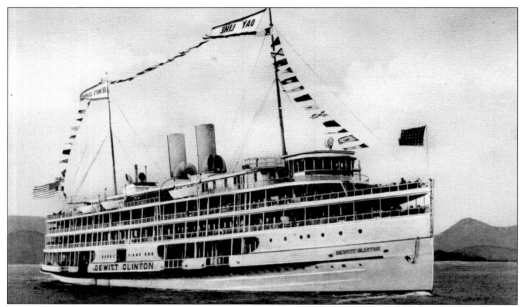

DAY LINE. Starting in 1913, the Hudson River Day Line began including Bear Mountain as one of its regularly scheduled stops in its daylight service. In 1918, the line added a regular Sunday boat. During World War I, upon arrival of the Sunday boat, patriotic services were held in one of the park pavilions. The *DeWitt Clinton* was one of many boats known for amenities such as dance music and fine dining service. (Schaut collection.)

EXCURSION. Companies frequently organized employee excursions to Bear Mountain. A 1919 PIPC report commented, "Such employees can count upon their return to work in closer fellowship and with a better spirit of cooperation. Petty differences are forgotten in happy remembrances of a really good time, of playful competition on the running track and the baseball diamond; and above all, of the dinner at the Bear Mountain Inn, with its accompaniment of music and song." (Hansen collection.)

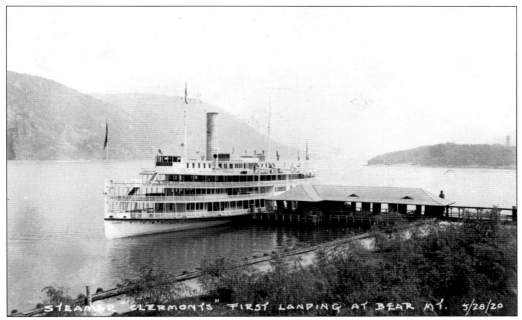

STEAMER "CLERMONT'S" FIRST LANDING AT BEAR MT. 5/28/20

CLERMONT. The steamer *Clermont*, pictured here on her maiden voyage, was one of two large riverboats owned and operated by the PIPC. With a capacity of 3,000 passengers, she made daily trips from New York City and Jersey City to Bear Mountain. George W. Perkins Sr. bought the *Clermont* and its sister, the *Oneonta*, with his own money and loaned them to the PIPC at no charge until repayment was possible.

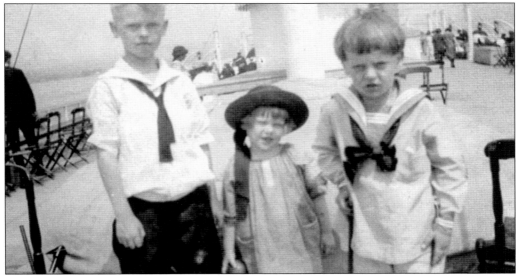

MILES CHILDREN. Day Line excursions to Bear Mountain were popular with travelers of all ages. Dressed for sailing, siblings John, Mary, and Edward "Pidgie" Miles of Manhattan enjoyed a summer trip to Bear Mountain aboard the *Washington Irving* in 1925. Below decks, the elegantly appointed interiors of the *Washington Irving* included an English pub lunchroom and the Alhambra Writing Room. The one-way trip took two and one-half hours. (Clark collection.)

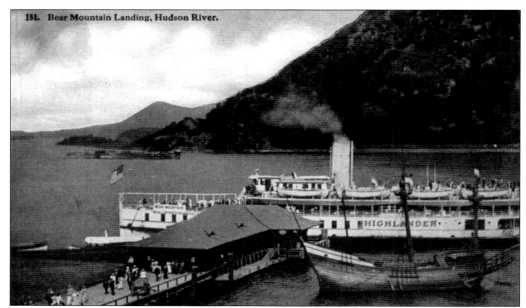

151. Bear Mountain Landing, Hudson River.

HIGHLANDER. Passengers are seen disembarking from the riverboat *Highlander* in this 1918 postcard. Operated by the McAllister Steamboat Company, the steel steamer had a capacity of 2,500 and sailed from the battery with stops in upper Manhattan and Yonkers. The schedule was arranged so the boat arrived before 1:00 p.m. and the public could enjoy a full afternoon. In the foreground is the *Half Moon* replica. (MacLeod collection.)

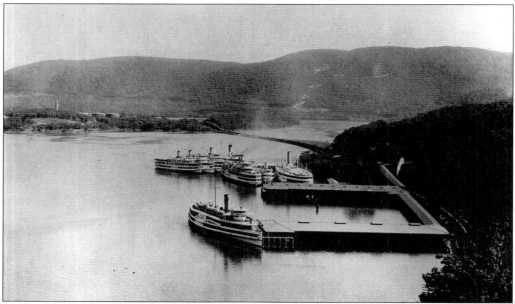

STEAMBOAT LANDING. Eight steamboats are docked at the expanded Bear Mountain facility around 1938. Known for elegant interiors and reliable service, the Hudson River Day Line was an integral part of life along the river for a century. Among the boats that stopped at Bear Mountain were the *Albany, Robert Fulton, Washington Irving, Mary Powell, DeWitt Clinton, Chauncey DePew,* and *Alexander Hamilton.* Steamboats from other lines used the dock as well.

58

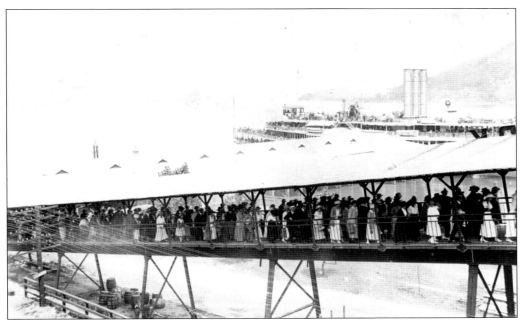

PEDESTRIAN WALKWAY. Ready for a pleasant day in the mountain air, pedestrians crowd the walkway from the dock to the main recreation area. The 12-foot-wide walkway was completed in 1915 to facilitate the climb to the playfield 130 feet above the river. It passed over the railroad tracks, a gorge, and a highway. It was dismantled in 1967.

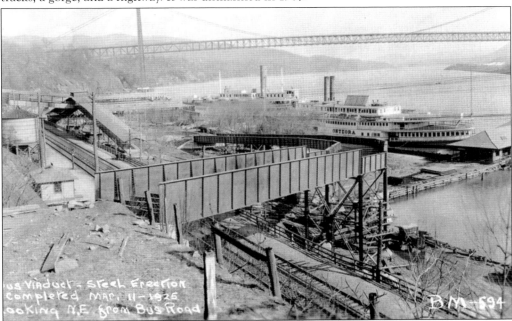

BUS VIADUCT. A bus road from the dock to the playing field was begun in 1925. The steel support structure for the viaduct over the West Shore Railroad tracks can be seen in its early stages. The *Clermont* and the *Onteora* are close by. Along with passengers, the boats carried camping equipment, baggage, and other supplies for a nominal charge.

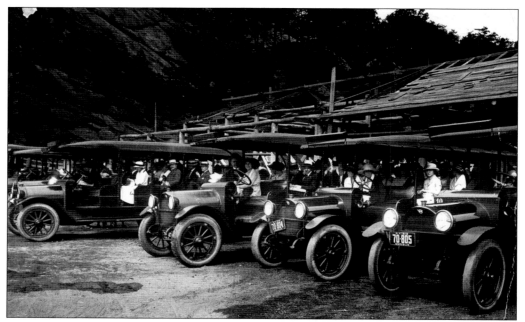

TOURING BUSES, C. 1918. A fleet of touring buses, owned and maintained by the park, was available to carry visitors from the dock up to the playfield, inn, lake, and picnic groves. The buses also took passengers for a delightful tour of Bear Mountain and Harriman State Parks on newly built scenic roads such as the Seven Lakes Drive.

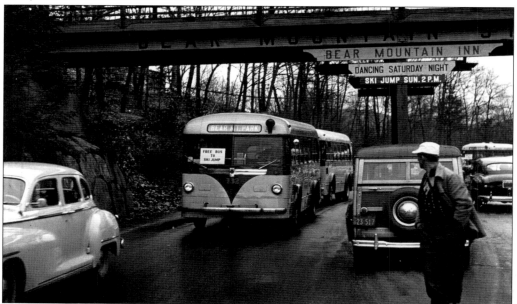

SKI BUSES. The popularity of ski jumping necessitated an inter-park bus system to move visitors from outer parking areas to the jump at Bear Mountain. The pedestrian walkway traffic came to a standstill on January 15, 1950, with so many eager winter parkgoers attending the Franklin D. Roosevelt-Harold Nelson Memorial Ski Jumping Tournament. Mild weather that year required the use of artificial snow.

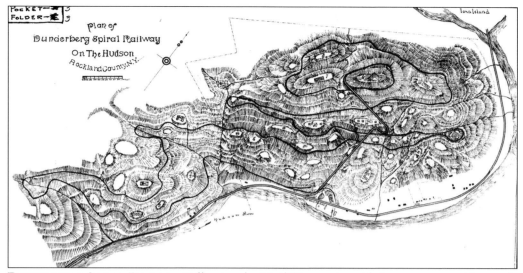

DUNDERBERG SPIRAL RAILWAY. Following the Civil War, nationwide interest emerged in scenic railways to the tops of mountains. In 1890, entrepreneurs began construction of a spiral railway on Dunderberg Mountain. Plans included a mechanical hoist of cable cars to the 930-foot peak followed by a gravity descent of nine miles. A resort hotel was planned for the summit. Lacking sufficient capital, the project was abandoned in 1891, but parts of the rail bed remain as hiking trails.

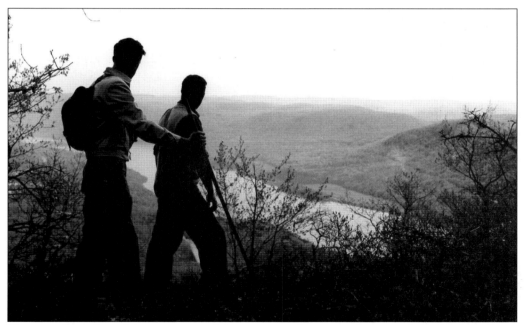

HIKERS. Atop Bear Mountain, two hikers survey the serene beauty of the Hudson River Highlands. A favorite spot for day hikers, Bear Mountain also contains a segment of the Appalachian Trail. "The spirit of the Highlands," wrote William Howell in 1906, "is exemplified by their trails, which far from detracting from the wildness of the forest, enhance it."

SIGHTSEEING MOTORS. Some of the park's 24 large "sightseeing motors" await visitors at the horseshoe turn above the playfield in 1924. Used as shuttles from the boat landing to the field, the fleet of vehicles was assembled, owned, and maintained by the PIPC. A 1920 brochure recommends taking the motors "on longer trips over the park drives through mountain valleys, along beautiful streams, and lake shores which make this section so charming."

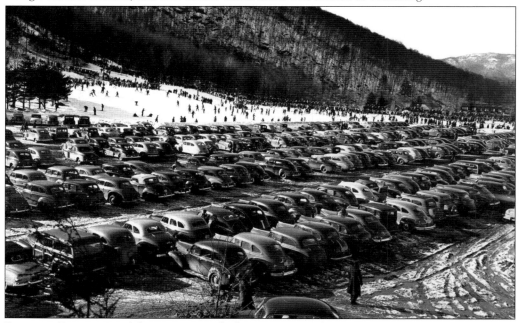

PARKING LOT, 1948. After a wartime decline in visitors due to gas rationing, the post–World War II winter seasons saw parking lots jammed with cars. Across the snowy field, lines of spectators can be seen at the ski jump and toboggan run. Others enjoy skiing on the open slope of the playfield.

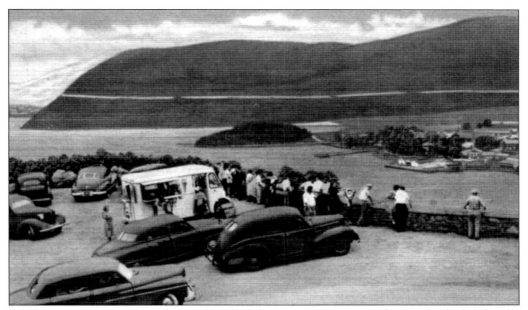

INSPIRATION POINT. Along the winding Peekskill-Bear Mountain Bridge Road, which is locally nicknamed "the Goat Trail," is an overlook called Inspiration Point. This 1952 postcard pictures motorists enjoying the scenic view of Iona Island and Bear Mountain. The three-mile-long road, blasted from the side of Anthony's Nose and Manito Mountain, connects the Bear Mountain Bridge with the Albany Post Road. (Carroll collection.)

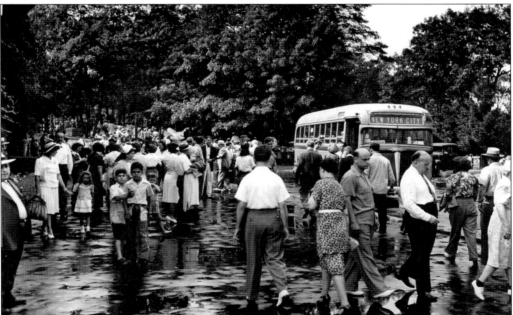

BUS STOP. Taking a bus from New York City was a common mode of transportation to Bear Mountain in the 1940s. On this July day in 1944, visitors arrived in front of the inn and then proceeded to the restaurant or picnic areas of their choice. Today regular service from Manhattan still brings hikers and picnickers to the park.

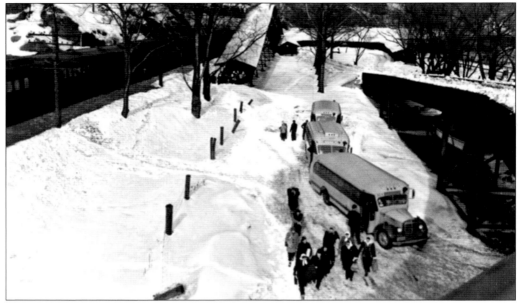

WINTER ARRIVAL. Undaunted by several feet of snow, winter visitors arrived by train on a chilly day in 1947. Buses were available to transport them to the ski jumps or the cozy warmth of the inn. Small but serviceable, the Bear Mountain station of the West Shore Railroad was established in 1915. Soon almost every local train along the west side of the Hudson River stopped at Bear Mountain.

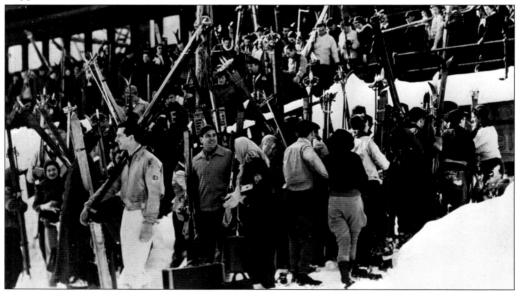

SNOW TRAIN, 1942. During the 1940s, fans of skiing flocked to Bear Mountain and Harriman State Parks on the weekends. Equipped with lace-up leather ski boots and wooden skis, sports enthusiasts arrived by the thousands on the "Snow Train" from Weehawken, New Jersey. Throughout the parks there were cross-country ski trails, including one that passed through Doodletown. At lunchtime, the walls of the inn's cafeteria were lined with skis while hungry athletes dined.

Six

SUMMER

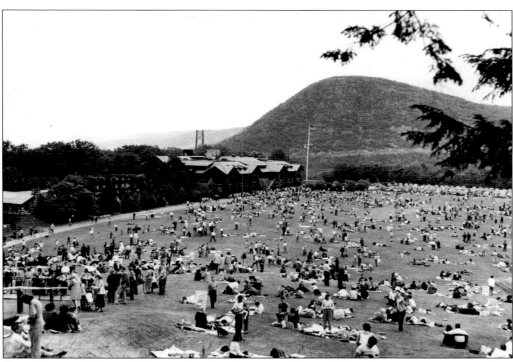

SUMMERTIME. Memorial Day weekend is the start of the ever-popular summer season at Bear Mountain State Park. It was hard to find a spot on the playfield when this picture was snapped on May 29, 1949. Facing eastward, the photograph looks toward Anthony's Nose. The largest building is the Bear Mountain Inn. At its left is Hessian Lodge, constructed as an annex to the hotel.

BASKET PARTIES. In 1914, picnic attire consisted of knickers for boys, long dresses for ladies, and white shirts and straw hats for men. Some fashionable visitors enjoy the swing set while others relax in the shade. Since picnickers commonly packed their supplies in baskets, such as the one in the right foreground, groups who came to spend the day together were called "basket parties."

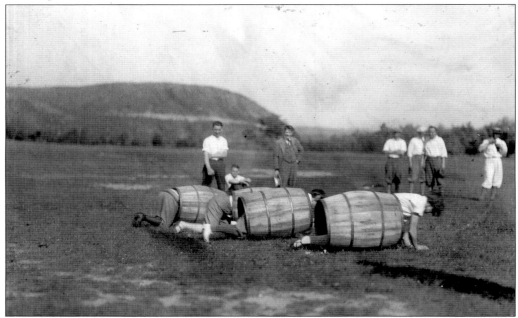

BARREL ROLL, 1925. In the 1920s, parkgoers participated in lighthearted games throughout the day. Above, four ladies roll out the barrels for some fun while amused gentlemen look on. Other activities available at this time were tennis, baseball, boating, hiking, camping, and a wading pool for children.

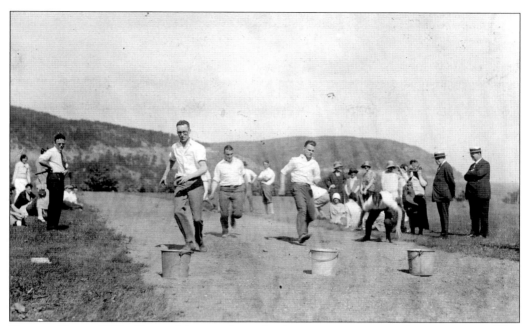

POTATO RACE, 1925. Competition was fierce for three men running in this potato race. This display of athletic and vegetarian prowess has drawn an appreciative crowd. In its first decade of existence, the number of visitors increased from 23,000 in 1913 to 2 million in 1922. Every year, the park commission purchased additional land to enlarge the park.

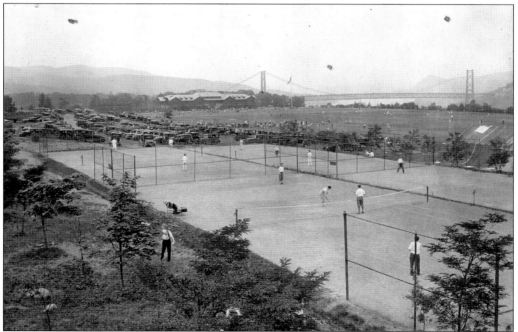

TENNIS ANYONE? With the Bear Mountain Inn and the new bridge as a backdrop, the tennis courts were busy on this hazy July afternoon in 1925. What would any tennis player feel about this glorious scenery? Love.

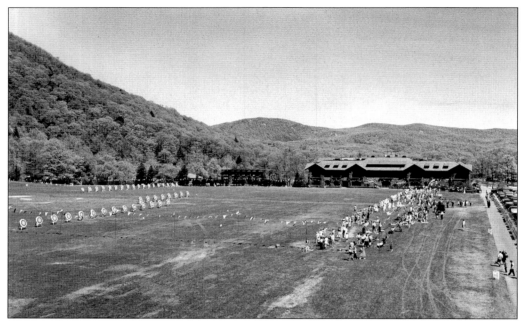

ARCHERY. After World War II, parkgoers took advantage of an expanded program of summer sports. In 1946, two tournaments were held, sponsored by the Metropolitan Archery Association. On the playfield above, lines of targets at varying distances were set up for the competition. Below, lady archers wearing quivers at their hips take aim in front of the inn. Bow stands set into the ground kept reserve equipment at the ready. Many of the female athletes had perfected their skills at nearby women's colleges such as Ladycliff and Vassar.

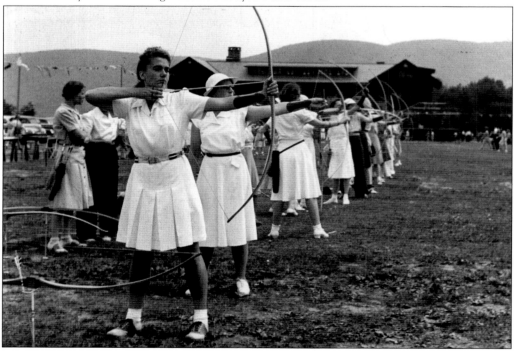

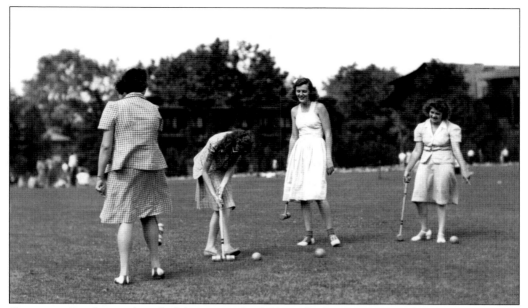

CROQUET. On the north end of the grassy playfield not far from Hessian Lodge, four ladies spent a summer's day enjoying a game of croquet about 1942. One young woman points to the wicket as her teammate strikes the wooden ball with the mallet. Skirts, suits, and saddle shoes were the proper feminine attire for a day in the country in the 1940s.

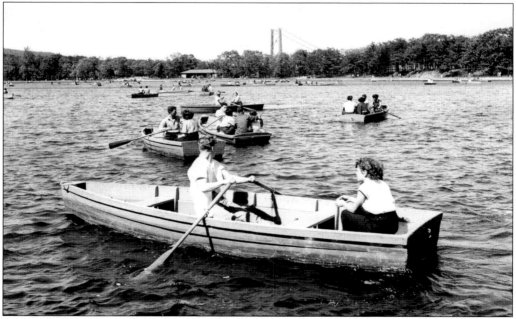

ROWBOATING ON HESSIAN LAKE. As Bear Mountain State Park was being created between 1910 and 1913, one of the first facilities built was a rowboat dock on Hessian Lake. For the first several years, boats made by park employees were available at no charge. A 25¢ deposit was collected and returned when the boat was brought back. Merrily rowing a boat gently down the lake remains one of the favorite activities at the park.

PIE-EATING CONTEST. The playfield was a perfect spot for a pie-eating contest on a summer day about 1926. A crowd gathered around the dozen young participants willing to face a piece of blueberry pie just for fun. (Hansen collection.)

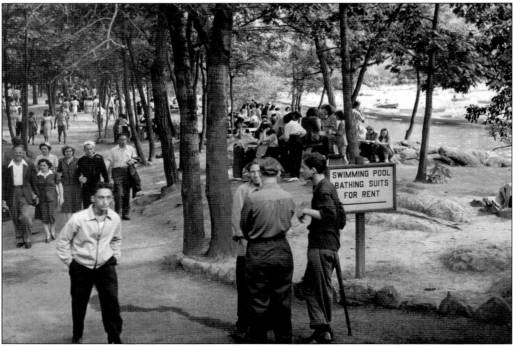

SUITS FOR RENT. A summer day in 1944 saw groups of visitors strolling, chatting, and picnicking in the grove on the east side of Hessian Lake. South of the amusement building there was a sign pointing toward the pool informing potential swimmers that bathing suits could be rented.

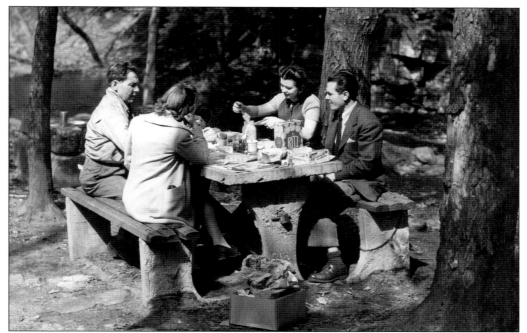

PICNIC, C. 1940. At a concrete table in a shady, lakeside picnic area, two couples enjoy a pleasant lunch of Ritz crackers, frankfurters, pickles, salads, and olives with Necco wafers and Campfire marshmallows for dessert. Sturdy concrete tables beside stone fireplaces were standard visitor amenities. Although picnic food has remained similar through the decades, picnic attire has not. Ladies in seamed stockings and gentlemen in ties are no longer commonplace.

STAND NO. 10, 1953. Known as Stand No. 10, this was one of several refreshment kiosks throughout the park. Visitors who preferred a quick snack rather than a meal at the inn could purchase popcorn, soft drinks, beer, hamburgers, hot dogs, and custard. Sundries and souvenirs of a pleasant summer outing were available on the left side of the stand.

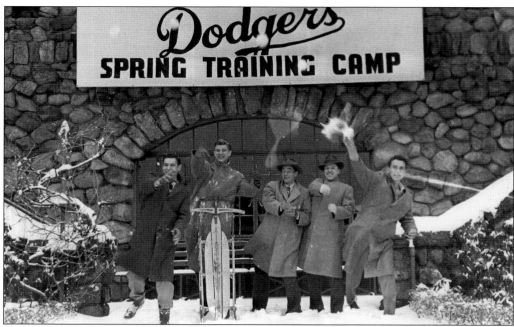

SPRING TRAINING. During World War II, Pres. Franklin Delano Roosevelt encouraged major-league baseball to continue as a morale booster for the American people. Wartime travel was restricted, so baseball teams who trained in Florida had to find a venue closer to home. From 1942 to 1945, the Brooklyn Dodgers used Bear Mountain for spring training. Tom Warren, Howie Schultz, Luis Olmo, Frank Drews, and Hal Gregg practice their pitching with snowballs in front of the inn. (Los Angeles Dodgers.)

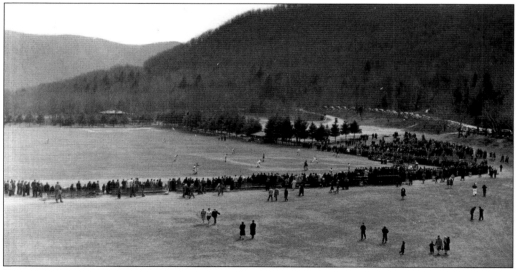

PLAYING FIELD. To accommodate spring training, the playing field at Bear Mountain was transformed into a baseball diamond, complete with bleachers for spectators. Jackie Robinson, the first African American to play major-league baseball, signed his contract with the Brooklyn Dodgers at the Bear Mountain Inn. On this field, Robinson took some of his first batting practices for the team.

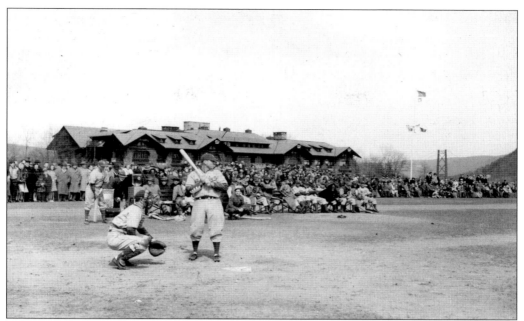

BATTER UP. Eager crowds gathered to watch the Brooklyn Dodgers practice during their first year of spring training at Bear Mountain. On this cold, March day in 1942, the batter awaited the pitch as his teammates looked on. Players recall watching people ice-skate while they worked out. In severe weather, batting practice was held at the West Point Field House.

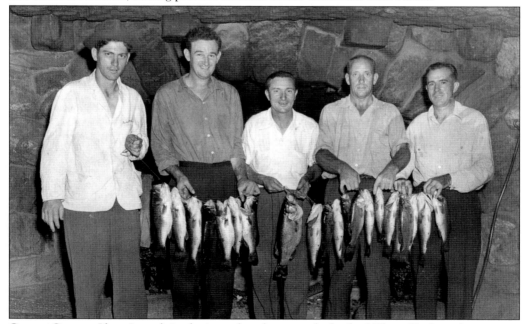

GREAT CATCH. If one's work is playing, what does one do for fun? These Dodger players went fishing and seemed as successful off the field as on. Five satisfied ballplayers hold on to the catch of the day in the spring of 1944. Their fishing guide on this trip was police captain James Gazaway, not pictured. (Wallace collection.)

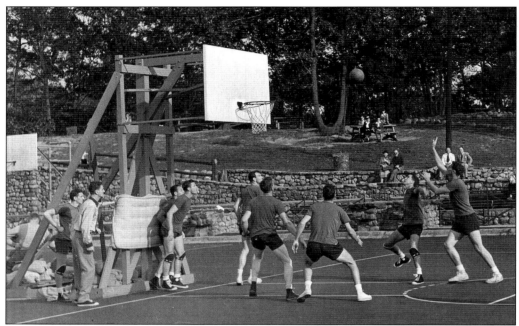

BASKETBALL PLAYERS. In the 1940s, the New York Knickerbockers were among the many teams who were invited by inn manager John Martin to use Bear Mountain as a training facility. Above, they are seen practicing their shooting skills on the basketball court along the south shore of Hessian Lake in 1947. The photograph below was taken 20 years later. By then, the basketball court had been relocated to the south end of the playfield near the administration building. Full of hoop dreams, some NBA hopefuls practiced their skills on that court on a warm day in August 1968.

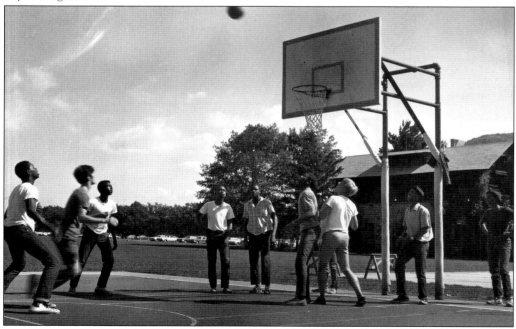

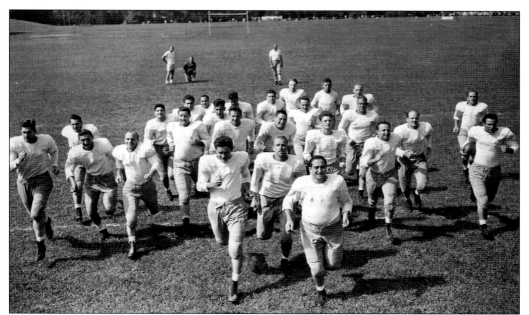

NEW YORK GIANTS. Sportswriters flocked to the Bear Mountain Inn during the 1940s and 1950s to report on the diverse teams who trained there. Telephones on the third floor were busy in the evening with correspondents calling in the stories to their newspapers. Here members of the New York Giants football team engage in a running drill opposite the inn.

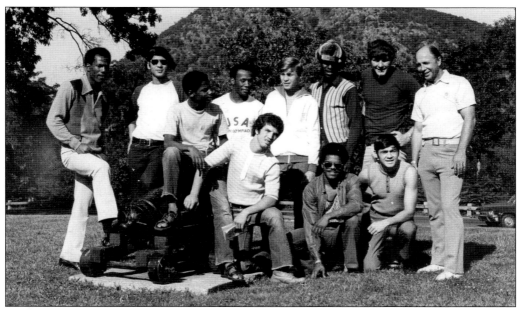

BOXING. A group of young men aspiring to be members of the U.S. Olympic boxing team trained at Bear Mountain prior to the 1972 Olympics. The park's sports tradition included a close relationship with both amateur and professional boxing. Bear Mountain regularly hosted the Eastern Golden Gloves team. World champion Jack Dempsey was a guest at the inn while recuperating from an illness.

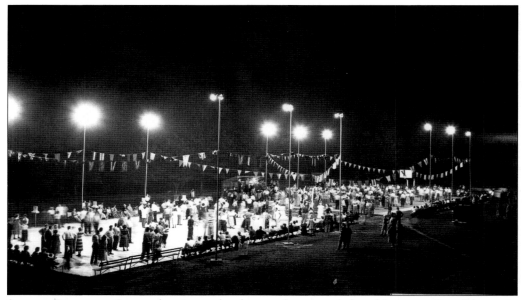

SQUARE DANCING. Square dancing under the stars became a beloved feature at Bear Mountain in the early 1950s and remained so for about 40 years. Local residents and summer vacationers enjoyed the dances, which were held on the basketball court or at the rink. One of the frequent callers was Slim Sterling. On this summer night in 1951, groups of eight get ready to do-si-do as local musicians tune up at the bandstand.

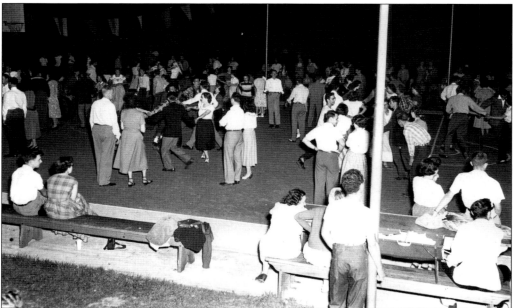

DANCING. "All join hands and circle left." Watching the dancers seemed to be almost as much fun as dancing on this evening in the early 1950s. The Bosch Bus Company of Highland Falls provided round-trip transportation to dancers from Haverstraw to Bear Mountain. "The buses were packed," recalls one former dancer. "That's why there were so many Haverstraw-Highland Falls marriages!"

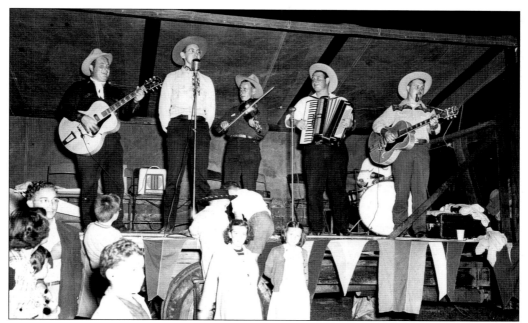

DANCE MUSIC. Two young fans try to climb onto the bandstand as six local musicians perform for the dancers. Through the years, the square dance nights changed from Thursdays to Wednesdays to Tuesdays. At the height of their popularity, dances were held three nights a week. The season usually ran from July 5 to August 30.

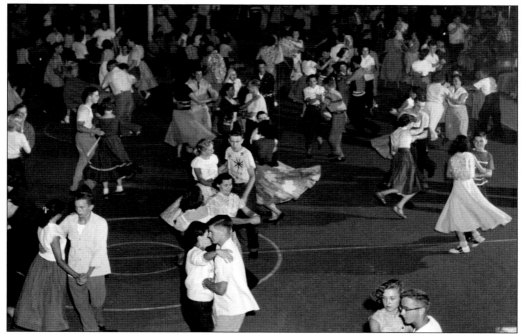

ROCK AND ROLL. In an effort not to be too square, time was made for a little rock and roll for these bobby-soxers in 1952. Ballroom dancing was offered during the 1960s. In case of inclement weather, the inn usually served as the backup venue.

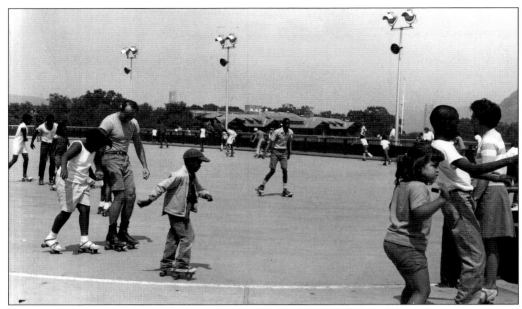

ROLLER SKATERS. Taking advantage of a fine August day in 1968, a group of skaters practice on the smooth concrete surface of the rink. Roller-skating hours were from 1:00 p.m. to 5:00 p.m. Admission for children was 25¢, and adult admission was 50¢. Imbedded in the concrete floor was a special system of pipes to freeze a layer of water applied to the surface for conversion to an ice rink in the winter.

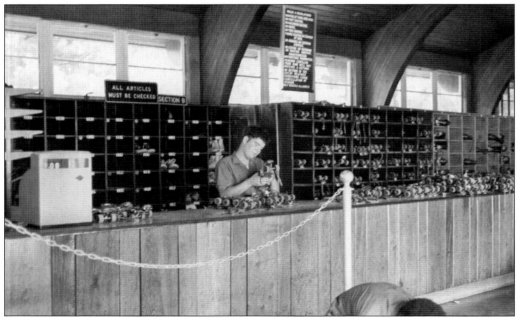

SKATE RENTAL. As part of his job at the rink, Edward Rafferty carefully checked the pairs of roller skates before they were returned to their storage compartments. Above him was a sign reminding skaters of the rules. No eating, drinking, fast skating, or backward skating were allowed. Rafferty worked at the rink during the early 1970s. (Photograph by Gregory Jones.)

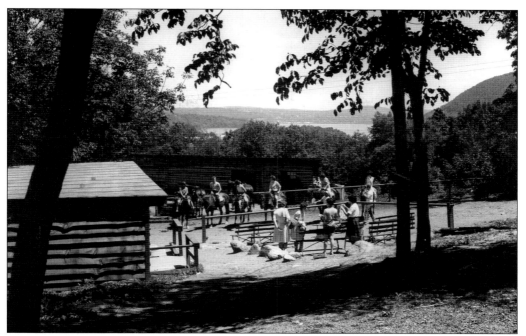

HORSEBACK RIDING. The Bear Mountain Riding Stables provided horseback riding opportunities. Riding was a favorite activity at the park for more than 30 years. In this photograph from June 1962, six equestrians prepare for a trail ride. The bridle path is now utilized as a hiking trail.

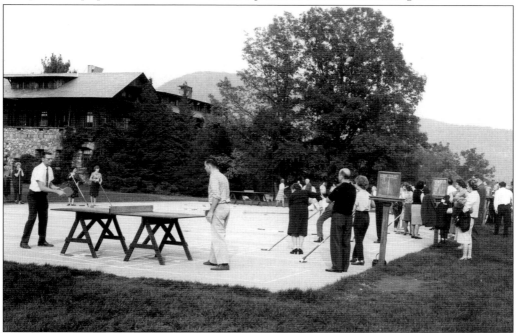

SHUFFLEBOARD. Adjacent to the basketball courts, the shuffleboard courts were a main attraction during the 1950s and 1960s. On this evening in 1962, Ping-Pong tables were set up as well. On certain weeknights, players yielded their courts to square dancers.

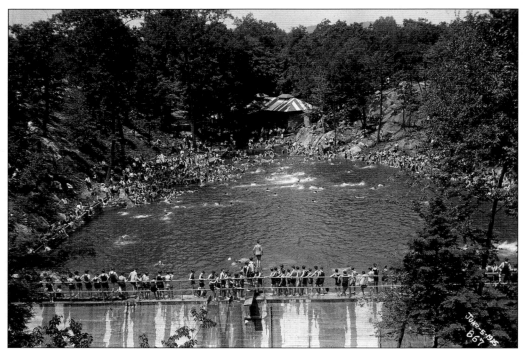

SWIMMING POOL. In 1924, a rustic swimming pool was constructed on a ledge between the playfield and the river. The pool, fed by water from Hessian Lake, became a major summer attraction and underwent several modifications over time. Above, some patrons swim while others sit on the rocky sides of the pool or wait to jump off the diving board on the dam. Below, a view of the pool in 1930 shows a bathhouse has been built.

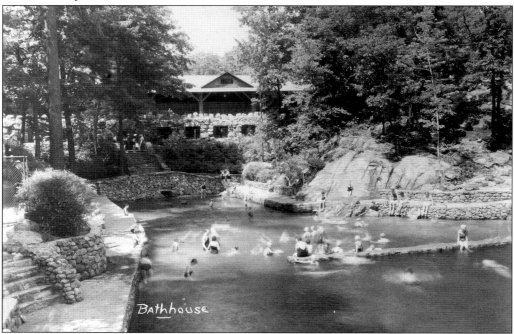

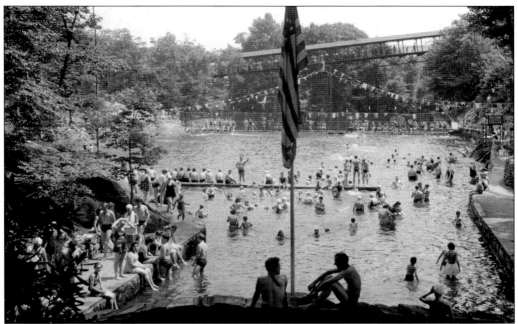

POOL RENOVATIONS. Above, the view looking south from the bathhouse in 1942 shows that benches and a fence have been placed on the dam ledge. A high diving board is visible just left of the flag. Behind the dam was the bear den of the zoo. Local residents recall that as children they were allowed to swim in the morning for free until the tourists arrived on the 1:00 p.m. boat. Overhead is the pedestrian walkway built early in the park's history to enable visitors to safely cross the railroad tracks. A swimmer at the pool in 1950 (below) sees quite a different facility. The sides have been widened, and the main pool has been lined with concrete. The high diving board is gone. The pool is still a well-used facility at the park.

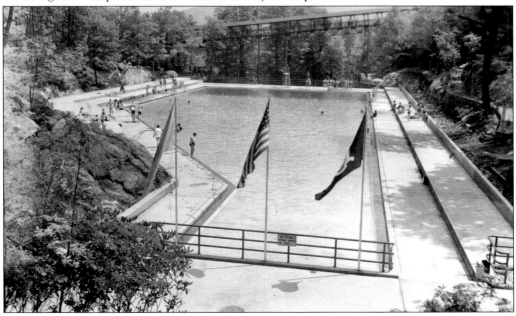

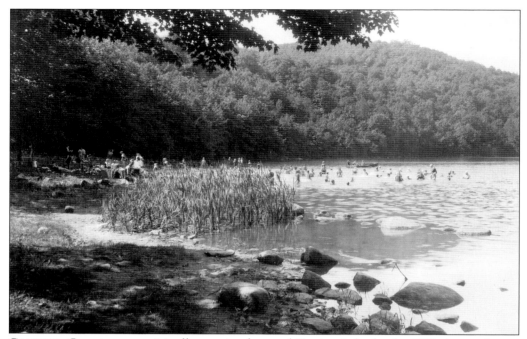

CAMPING. Camping was originally permitted around Hessian Lake, but by 1920, the conditions had become so crowded that most camping was restricted to Harriman State Park and to Bear Mountain's properties along Popolopen Creek and Brooks Lake. Camps were patrolled and protected by the police night shift, nicknamed the "mosquito patrol." Above, campers enjoy a cool dip in Brooks Lake in 1930. Below, a vintage postcard shows Camp Brentmere, one of many camps that the PIPC leased to various organizations. Barnard College utilized this cabin from 1922 to 1926 to provide a retreat for its students. "Intellectual challenges of an academic life," wrote one alumna, "are closely linked to physical and outdoor activities." (Above, Hansen collection; below, Carroll collection.)

Seven

WINTER

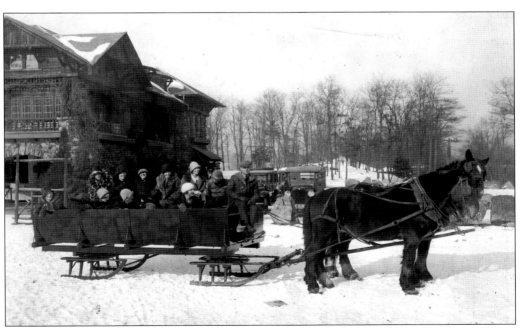

OPEN SLEIGH, 1926. Dashing through the snow in a two-horse open sleigh, a party of ladies takes in some fresh winter air. To make itself into a year-round recreation destination, Bear Mountain State Park established its winter sports program in 1922 and 1923. Facilities were provided for tobogganing, skiing, snowshoeing, ice-skating, and sleighing. Until 1922, the park was almost deserted in the cold months. By the winter of 1928–1929 more than 500,000 outdoor enthusiasts visited the park.

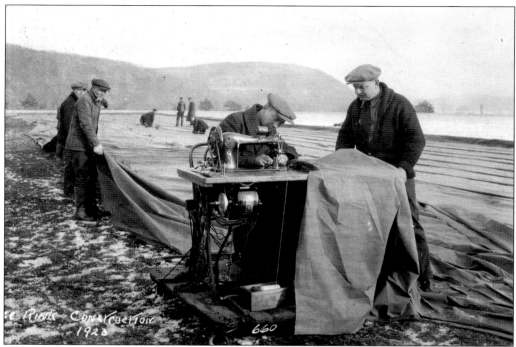

ICE RINK. The first ice rink created at the park consisted of a giant tarpaulin sewn on site, laid on the playing field, and filled with water from Hessian Lake. Using an electric Singer sewing machine with a foot pedal, the craftsman (above) joins the panels of sturdy fabric. Below, an engineer using surveying equipment oversees the alignment of the rink.

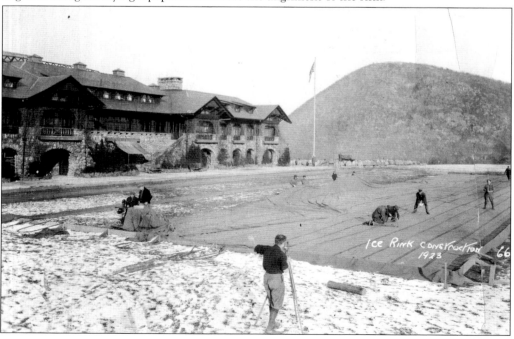

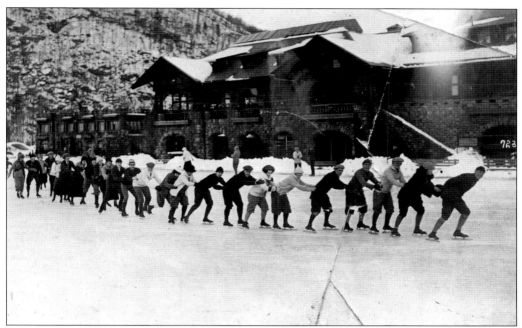

IN-LINE SKATING. In-line skating had a different meaning in 1923. A parade of exuberant skaters crosses the ice beside the impressive stone facade of the inn, which had just been converted for winter accommodations. Hessian Lake was also used for skating.

FROZEN WATERSKIING, 1924. In an amusing imitation of waterskiing, a vehicle tows four lady skiers and three gentleman tobogganers across the snowy landscape at the base of Bear Mountain. The immediate popularity of winter sports was gratifying to the PIPC commissioners, who were committed to serving the public in winter as well as summer.

WINTER SPORTS. This 1936 brochure reminded potential visitors that Bear Mountain Park was a mecca for winter sports. "Here one may enjoy tobogganing, snowshoeing, and ice skating on an artificially frozen rink. The north slope of the Perkins Memorial Drive and the Doodletown Trail are open to the public for ski running. Toboggans, skis, sleds, snowshoes and flexible flyers may be rented on the premises at reasonable rates."

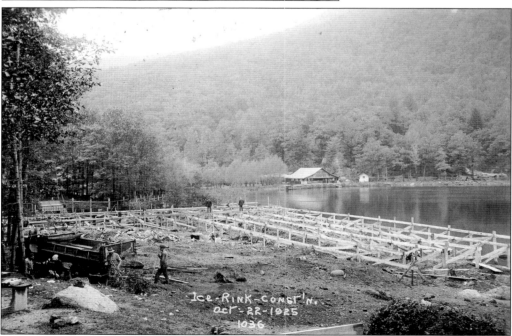

NEW ICE RINK. In 1925, a new rink was built on the south shore of Hessian Lake. Measuring 100 by 200 feet, it was designed to be suitable for hockey. Two tiers of stone benches were constructed for spectators.

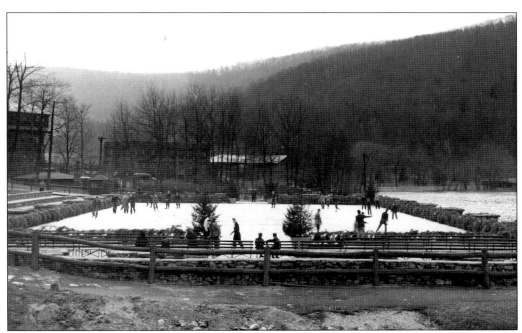

ICE RINKS. The location of the ice rink changed over time. Above, in a photograph taken in 1942, the rink is positioned on the shore between the inn and Hessian Lake. Surrounded by a stone wall, the skaters enjoyed a scenic mountain panorama. This rink replaced an earlier enclosed rink in the same spot that was destroyed by fire about 1941. A shortage of building materials due to World War II necessitated the rebuilding of an open-air rink using the undamaged piping and refrigerating equipment of the former rink. Below, a photograph taken in 1961 shows the relocation of the rink to the southwest area of the playfield where it is today.

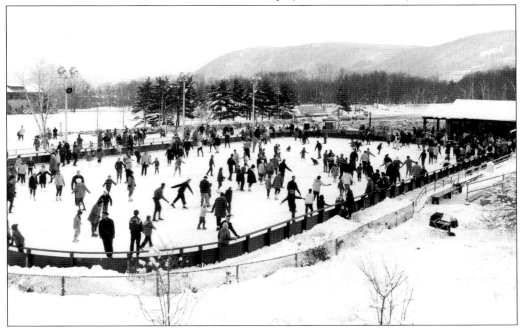

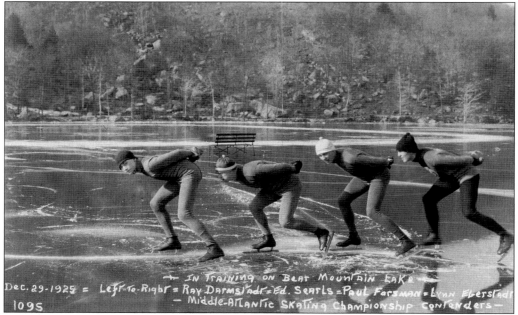

In the photo, handwritten text reads:

→ IN TRAINING ON BEAR MOUNTAIN LAKE →
Dec. 29-1925 = Left-To-Right = Ray Darmstadt = Ed. Searls = Paul Forsman = Lynn Eberstadt
— Middle-Atlantic Skating Championship Contenders —
1095

SPEED SKATING. During the winter of 1925–1926, the winter sports program was augmented by the organization of speed skating meets sanctioned by the Middle Atlantic Skating Association. From left to right, Ray Darmstadt, Edward Searls, Paul Forsman, and Lynn Eberstadt train for the championships on Hessian Lake in December 1925.

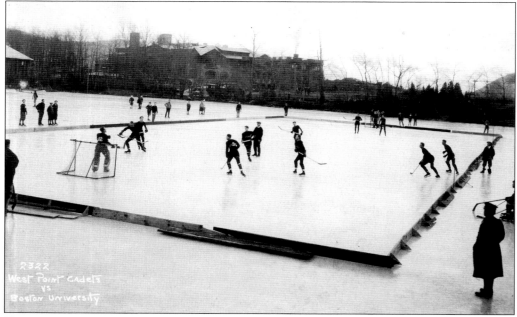

In the photo, handwritten text reads:

2322
West Point Cadets
vs
Boston University

HOCKEY GAME. During the 1920s, cadets from the United States Military Academy at nearby West Point played ice hockey on Hessian Lake. This game against Boston University took place in 1926. Boundaries had been created by a portable wooden frame. The cadet team was coached by Ray Marchand. Boston's coach was George Gaw.

ICE HARVEST. Park foreman William H. Hannigan operates a power-driven Gifford saw on Hessian Lake in January 1926. Other workers are seen using manual saws. Ice harvesting was a common sight in the Highlands before the widespread use of refrigerators in the 1940s. After cutting, the blocks were maneuvered to shore with long-handled ice forks where they were removed by conveyor for storage in the park's icehouse. The ice was used at the inn and refreshment stands. In the summer, chunks of ice were added to barrels of water placed around the park to provide cold drinking water.

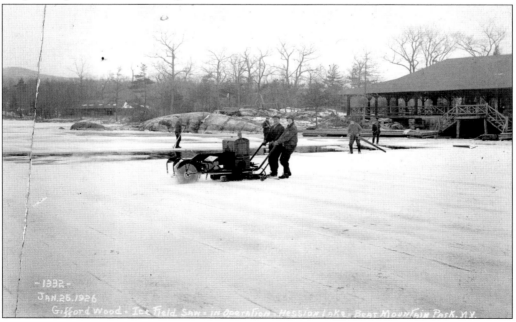

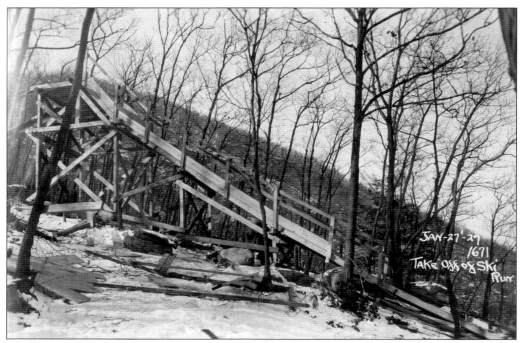

SKI JUMP. In 1927, construction began on a ski jump designed by Swedish and Norwegian engineers from the Scandinavian Ski Association. The hill just below the takeoff was angled at about 30 degrees for optimum performance. Ski jumping championships began that year and became one of the park's major attractions for decades to come. In the view below, taken in 1950, fans crowd the landing area. Four toboggan runs are seen at left. People are lined up at the sports equipment building where items were available for a nominal rental fee.

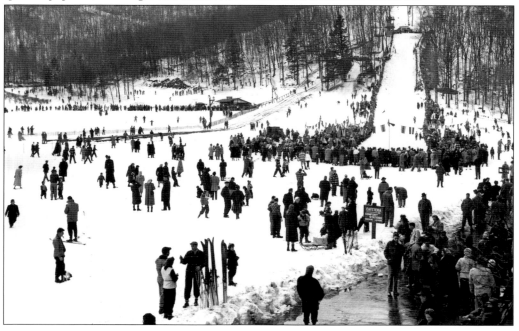

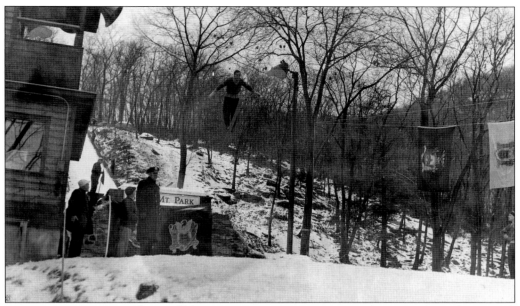

INTERSTATE JUMPING. Flying off the jump, James Hannigan soars above the flags of New York and New Jersey. Interstate ski Jumping championships attracted entrants of the highest caliber. The judges' booth is at left. Tabulators on the first floor kept statistics on each jump. On the slope, Thomas McGovern waits to flag the next jumper. The loudspeaker carried the voice of Waldo Wood, a Highland Falls teacher who worked as an announcer. (James Hannigan collection.)

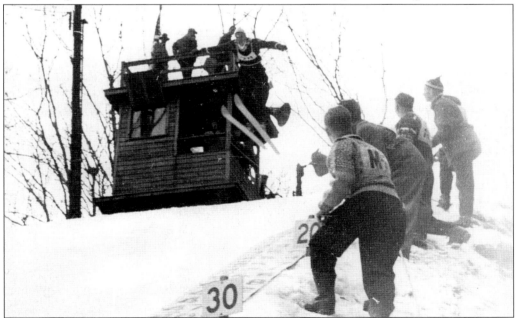

SKI JUMPING. Local jumpers opposed European skiers in the competitions. As judges observe his form and distance, Garry Lent, a champion from nearby Fort Montgomery, takes flight over the snow in 1956. As each skier landed, a pole was slapped down to mark the landing spot that was then compared to a measurement tape along the side. (Lent collection.)

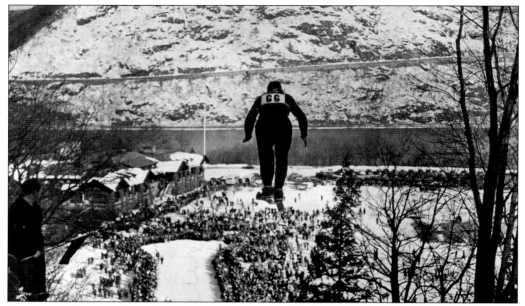

FACILITIES. Jumpers from far and wide enjoyed competing at Bear Mountain. Its beauty was legendary but so were the comforts. Unlike other venues, facilities were centrally located. While waiting for their turn, skiers and their families could keep warm at the inn. The cafeteria was readily available for a hot drink or a bite to eat. After the Sunday meets, the Bear Mountain Inn hosted a sumptuous dinner for competitors and their guests.

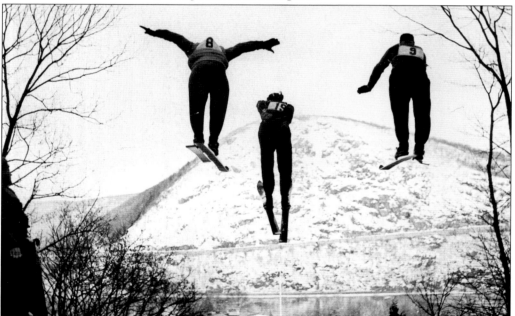

TRIPLE JUMP. Three jumpers at a time was an unusual and dangerous trick in ski jumping. Bear Mountain was one of the few places where it was performed. Timing was critically important because skiers began the jump holding hands and had to remember to let go at exactly the right point. Affected by budget cuts, the last ski jumping season was the winter of 1990–1991.

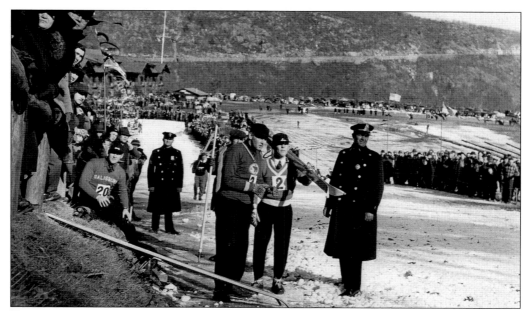

TEAMMATES, C. 1940. Sporting team sweaters of the Bear Mountain Sports Association, Karl Holstrom (left) and Torger Tokle eagerly await the next jumper. Behind them stands Edward Storms. Police captain James Gazaway (right) and an unidentified officer enjoy the event as they maintain crowd control. After jumping, athletes carried their heavy skis up a steep flight of steps to the top of the 55-meter hill for their next turn. (James Hannigan collection.)

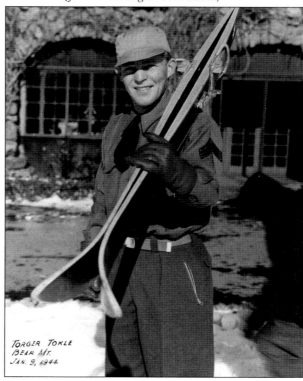

TORGER TOKLE. Called "the Babe Ruth of Ski Jumping" by sportswriters, Torger Tokle was considered the greatest distance jumper ever to compete at Bear Mountain. In 1942, he set a record of 180 feet that remained unbroken for over 20 years. Tokle was killed during World War II, serving with the ski troops of the 10th Mountain Division of the Fifth Army. In January 1944, he posed proudly in his uniform beside the Bear Mountain Inn.

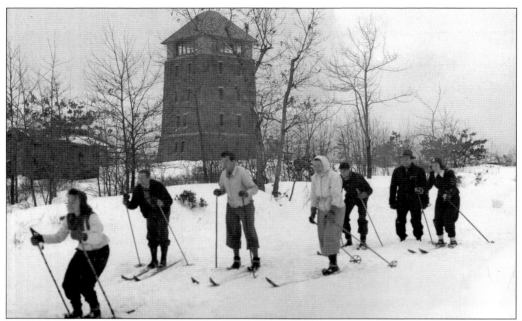

SKI PERKINS. The picturesque summit of Perkins Mountain was a favorite spot for skiers during the 1940s and early 1950s. Leaving the Seven Lakes Drive side open for traffic, the Palisades Parkway side of the mountain was closed to enable visitors to ski down the entire way. Later many enjoyed a warm drink by the cozy fire of the Bear Mountain Inn.

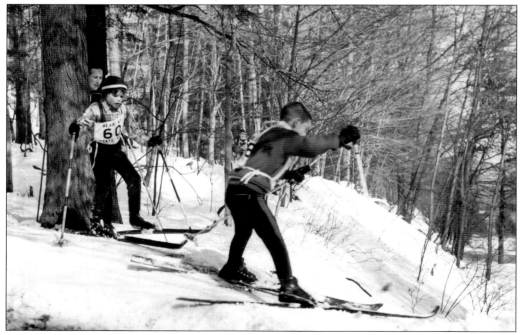

JUNIOR SKIERS. The New York State Junior Cross Country Ski Championships were held at Bear Mountain in February 1967. An observer watches intently as two boys carefully negotiate a small hill on the trail.

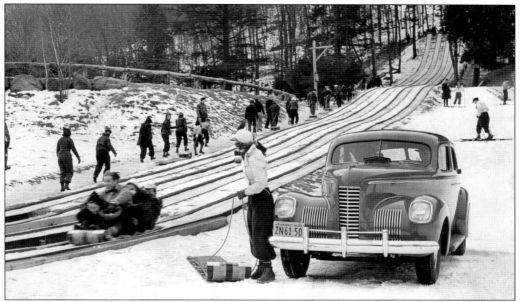

TOBOGGAN RIDE. PIPC commissioner Averell Harriman had a special parking place for his new Nash on an official visit to the park in 1939. Sliding down the icy chutes on the runnerless wooden sleds was a favorite activity for day visitors. At the top of the slope, the chutes were quite steep in order to accelerate the toboggan. At the bottom the tracks flattened out, separating into a fanlike shape.

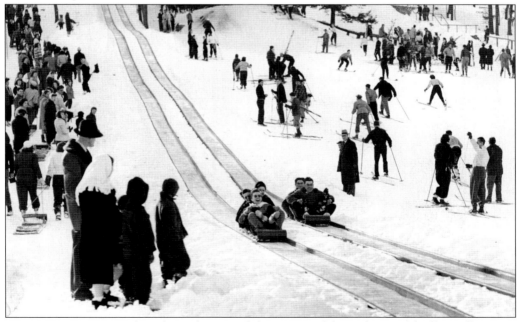

TOBOGGAN SLIDE. Hurtling down the steep slide was one of the park's most thrilling offerings, a fact to which these 1945 visitors can attest. The exciting toboggan run was over 1,000 feet long with a thrilling finish. Local children waited until nighttime under the lights when the chutes were frozen hard for a particularly speedy descent.

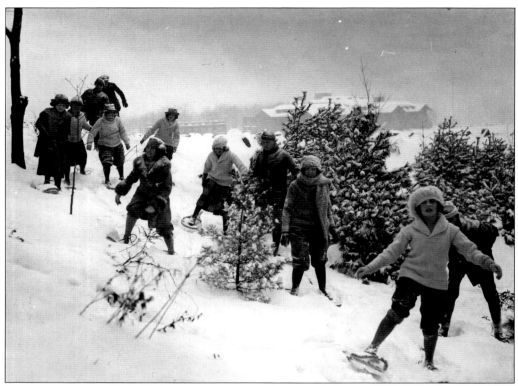

SNOWSHOEING, C. 1930. Twelve novices practice their new skills on a hillside across the playfield from the Bear Mountain Inn and Hessian Lodge. Snowshoes, along with toboggans and ice skates, were readily available for a nominal rental fee starting in 1922.

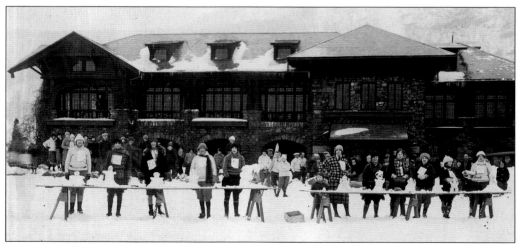

SNOWMAN CONTEST. Participants in a snowman-making contest pose behind their frosty creations in January 1924. The inn organized a schedule of contests and events to supplement the winter sports program in order to provide something for everyone to enjoy. (Hansen collection.)

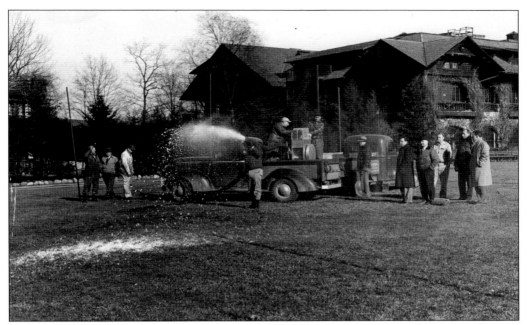

SNOWMAKING. Snowmaking became a necessity during warmer winters, as ski jumping became the main winter event at Bear Mountain. Above, a 1951 photograph shows workers from the Garnerville Ice Company of Haverstraw, New York, loading blocks of ice into a snowmaking machine. Seen below, by 1962, the process had become more mechanized. Snow was provided by the Larkin Ice Company of Newburgh. The high cost of snowmaking was one factor that led to the end of ski jumping at the park.

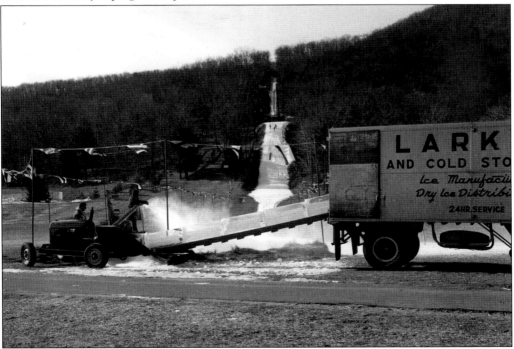

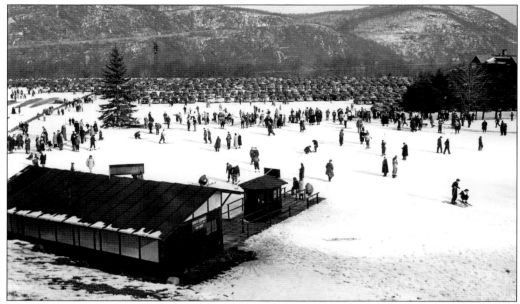

EQUIPMENT RENTAL, 1949. To enable visitors to take advantage of the numerous sports opportunities, rentals could be arranged at the sports equipment building beside the 17-acre playing field. The rate for toboggans and Flexible Flyers was 50¢ per hour. Sleds, skis, and snowshoes could be rented for 25¢ per hour. Bear Mountain's advertising brochures stated, "There is no limit to the number who can be entertained at one time."

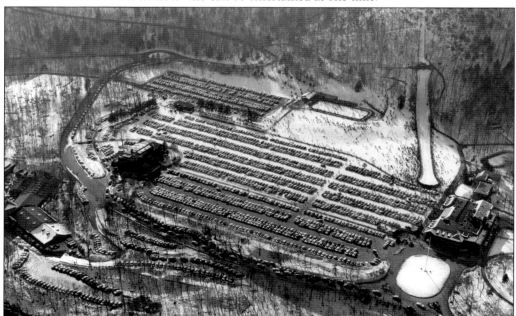

AERIAL VIEW. This aerial view of the park was taken during the winter of 1948. At the right are the inn, the Hessian Lodge, and the inn manager's home. Left of center, near the playfield, is the PIPC administration building. At lower left are the post office and maintenance buildings, one of which was a dormitory for workers during the 1940s and 1950s.

Eight

SERVICE

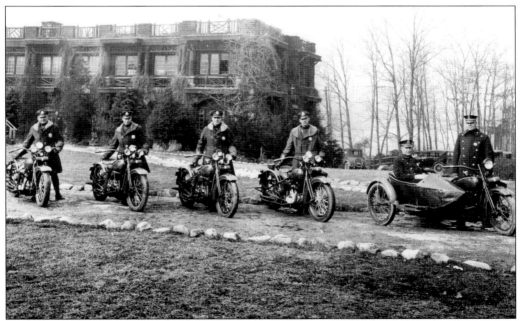

PARK POLICE. Chief E. Mandigo (right) and Lt. W. Alu (seated) join four patrolmen of the Palisades Interstate Park Police Department posing proudly beside their motorcycles in front of Hessian Lodge in 1927. Police patrols assisted motorists and park users, enforced laws, maintained safety and security at the park and the camps, conducted criminal investigations, and provided emergency road services.

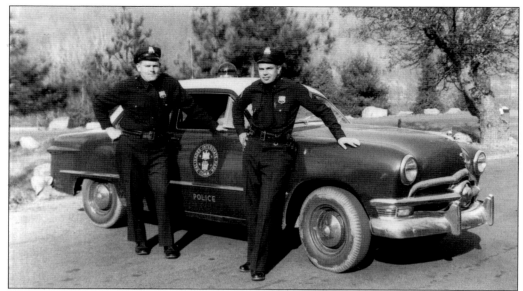

PARK PATROL. Officers Joseph Trainor and Erling Sandstrom of the Palisade Interstate Park police pose beside their patrol car about 1950. Aside from patrolling the roads of the park, police had the added responsibilities of being the fire department and ambulance squad within Bear Mountain, Harriman, Rockland Lake, Tallman, and other PIPC parklands in the region. Bear Mountain State Park served as the administrative headquarters for the surrounding parks. (Sandstrom collection.)

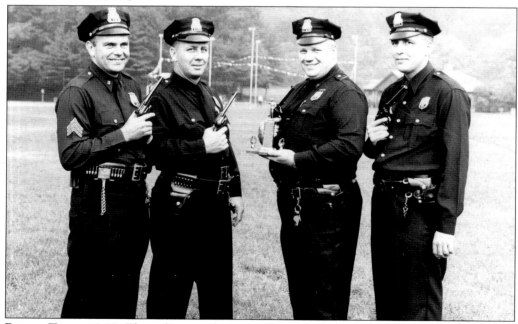

PISTOL TEAM, 1960. The police pistol team at Bear Mountain has maintained a tradition of excellence for decades. Holding one of many trophies earned in competition, from left to right, are Sgt. Erling Sandstrom and officers Max Stroppel, Noel desRosiers, and Frank Thornton. (Stroppel collection.)

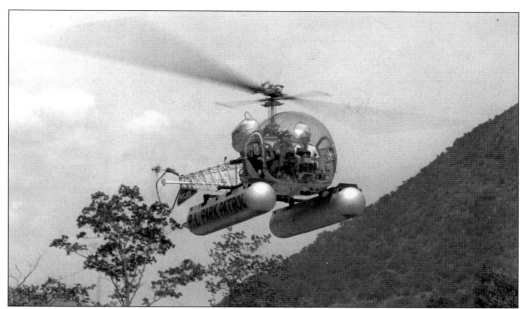

POLICE HELICOPTER. Fire is an ever-present danger within the park. Helicopter searches aided in fire prevention, search and rescue, traffic control, and maintaining the safety of campers. In this 1972 photograph, officers Gene Harrington (left) and Sandstrom embark with an unidentified pilot on a routine surveillance, which included flying over isolated lakes to discourage illegal swimming. The helicopter was based at Iona Island. (Sandstrom collection.)

TRAINING SESSION. The Palisades Interstate Park system contains over 30 lakes and ponds as well as the shores of the Hudson and Ramapo Rivers. The park police activated a scuba team from 1970 to 1984. Pictured here at a training session are James Clark, Andrew Smith, David Love, and an unidentified trainer. Not pictured is scuba team leader Gregory Stewart. (Reberholt collection.)

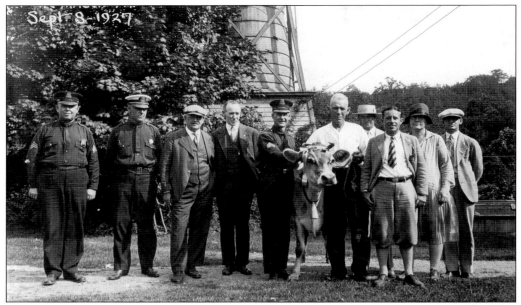

RETIREMENT GIFT. Upon his retirement from the force in 1927, PIPC police chief William Gee received a most useful gift. Since Gee was planning to reside on a farm, he was presented with a dairy cow by his staff and friends. Flanking the beribboned bovine are Captain Drew (left) and Gee (right). A letter accompanying the gift wished the chief a happy retirement full of the "milk of human kindness." (Gee collection.)

FIRE ENGINE. In response to a need for fire equipment, this Dodge touring car was converted into a fire truck in 1926. Park staff fitted out the vehicle with a two-inch hose and an Evinrude gas engine pump in the rear to create a fire engine.

CAMPFIRE TONIGHT. Pulling four loads of wood, a truck makes its way within Bear Mountain and Harriman State Parks about 1918. The clearing of areas for camps and trails generated a significant amount of timber and dying chestnut. It was used in the construction of docks, rustic benches, fence rails, telephone poles, and wood for campfires enjoyed by thousands annually.

CHRISTMAS TREE. In anticipation of a busy holiday season, maintenance workers adjust the star atop the Christmas tree, making it perfect for its debut during the first weekend of December in 1978. Abundant decorations outdoors and inside the inn required time and effort but were a major attraction for parkgoers.

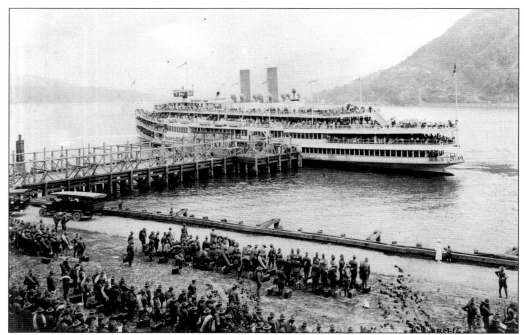

ARMED FORCES. Whenever necessary, the park commission offered its facilities to aid the U.S. Armed Forces. Above, World War I troops carrying bedrolls, tents, and personal effects watch the Hudson River Day Line steamer *Hendrick Hudson* dock at Bear Mountain. They wait in readiness for transport to New York City en route, most likely, to Europe. Below, on June 16, 1927, two battalions from the 104th Infantry, 27th Division of the New York National Guard camped overnight on the playing field at Bear Mountain. Support vehicles, including ambulances, parked along the perimeter.

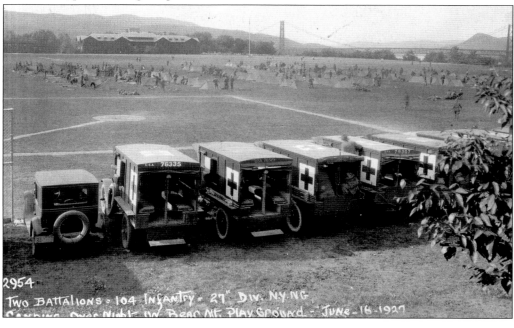

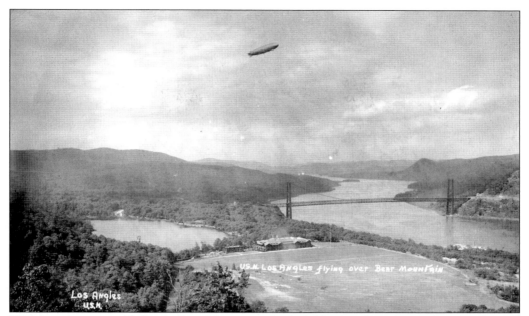

USS LOS ANGELES. Aloft over Bear Mountain, the U.S. Navy airship *Los Angeles* was captured in this rare photograph about 1926. The helium-filled dirigible was utilized by the navy to calibrate radio compasses and fly regular missions along the East Coast for that purpose. Among the navy facilities along the rigid airship's route was the munitions depot at Iona Island.

F.D.R. In October 1934, Pres. Franklin Delano Roosevelt (seated left) came to Bear Mountain with his wife, Eleanor, to dedicate the George W. Perkins Memorial Highway. At the ceremony, he thanked Linn Perkins for providing the funds and the WPA for the labor to create the Perkins Memorial Tower. Roosevelt had been a supporter of the PIPC since his term as governor of New York, believing that outdoor recreation relieved the strain of living in overcrowded cities. "The park idea," he once said, "is essential to American civilization."

SCOUTING. Camping was a major activity at the park from the moment it opened. To assist campers, the PIPC built tent platforms and fireplaces around Hessian Lake. By 1920, overcrowding was a problem at the lake so camping was moved elsewhere. Between 1920 and 1946, Girl Scouts from New York City and Campfire Girls from New Jersey occupied sites on Popolopen Creek and Brooks Lake. Here eight neatly uniformed tent mates line up for inspection.

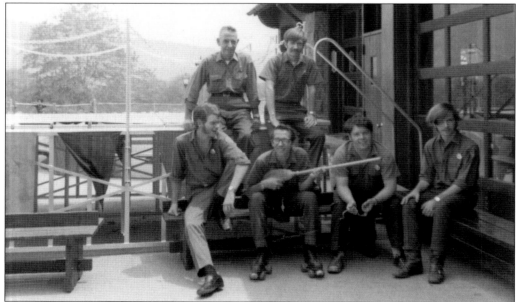

GREENIES, 1970. Known as "greenies" because of their green uniforms, park workers pause for a break by the skating rink office in 1970. Greenies had maintenance and groundskeeping responsibilities. Many of the seasonal employees were from local communities. Seated from left to right are (first row) Ray Count, Kevin Wood, Edward Rafferty, and Thomas Jones; (second row) manager Jim Beeman and Gregory Jones. (Olivia collection.)

LIFEGUARD. One of the first two female lifeguards at the Bear Mountain pool, Mary T. Hannigan posed for this photograph in 1945. Behind her is the west side lifeguard stand. In the distance is the bathhouse. (William Hannigan collection.)

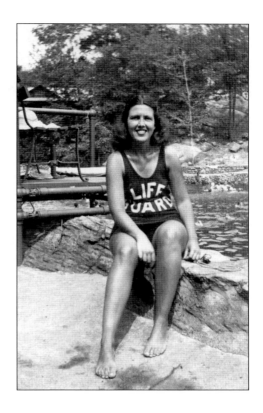

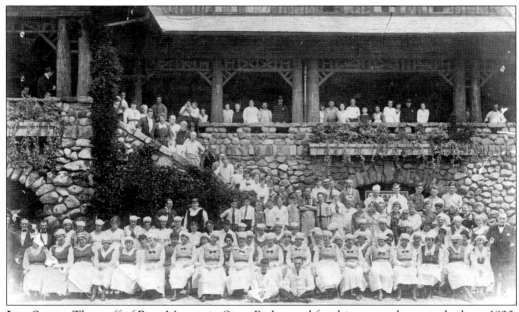

INN STAFF. The staff of Bear Mountain State Park posed for this group photograph about 1920. Among those pictured are waitresses, bartenders, maids, chefs, park police, and administrative staff. Some of the help lived on site, occupying rooms on the top floor of the inn.

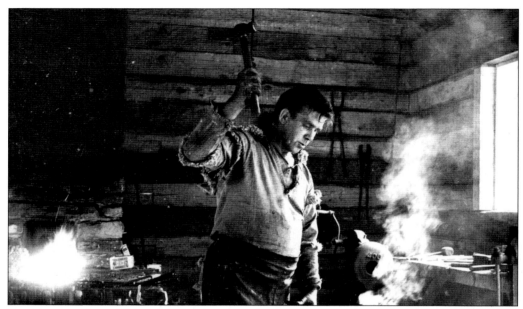

BLACKSMITH SHOP. Heinrich Schreiber raises his hammer to work on an axe blade at the park's blacksmith shop in 1965. All ironwork for buildings, dams, and other projects was created on site. He was part of a long line of fellow craftsmen. In fact, as early as 1920, a PIPC report mentions the construction of "a new blacksmith's shop." Schreiber, whose responsibilities included making and repairing tools, gates, and machinery, was the last blacksmith on the state payroll.

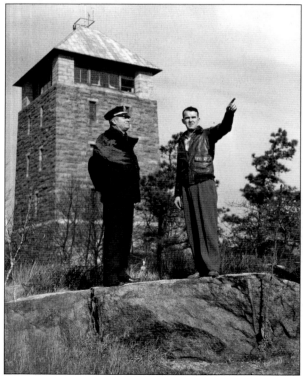

WEATHERMAN. Police captain James Gazaway (left) discussed the forecast with park weatherman William Kennedy atop Bear Mountain in 1950. The 65-foot Perkins Memorial Tower, at the time an active weather station, stands behind them. Kennedy worked year-round at the tower and met the challenge of getting to work in winter with the help of park rangers. Although no longer used for collecting atmospheric data, the observation tower can be used for forest fire surveillance. (Wallace collection.)

ADMINISTRATION BUILDINGS. The busy staff of the park's administration office poses for a photograph in 1933. Employees worked on the top floor of the Hessian Lodge keeping records of finances, schedules, services, equipment, and park attendance. On the hat stand (rear right) a straw hat, rackets, and tennis shoes await employees who will enjoy the park after work. Hessian Lodge became a hotel annex when a larger, more modern administration building was constructed in 1935. The stately structure (below) remains in use as the central office building for the park, housing both administration and police. Computers have replaced adding machines, ledger books, and typewriters.

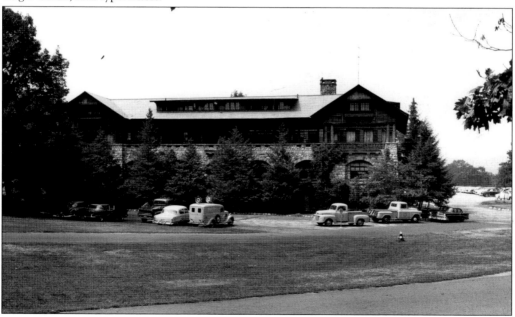

CONSERVATION. From its inception, the PIPC was concerned with conservation. Reforestation of mountains denuded by woodcutters was one of the first initiatives, quickly followed by attempts to restore and maintain animal species and habitat. The desperately hard winter of 1947 endangered deer in particular, so an effort was made to prevent mass starvation. Pictured at left, park ranger James Ossman provides hay for the deer. In 1920, an effort was made to repopulate Bear Mountain with beavers that had been trapped into extinction in the area. By 1948, the beaver population had become too numerous within the park. Below, Ossman (left) and Capt. James Gazaway are pictured. They are involved in a catch and release program to relocate the animals to areas where they could not block culverts or destroy campsites. (Wallace collection.)

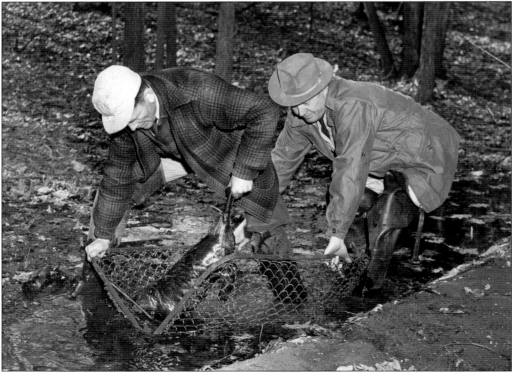

Nine

TRAILSIDE MUSEUMS AND ZOO

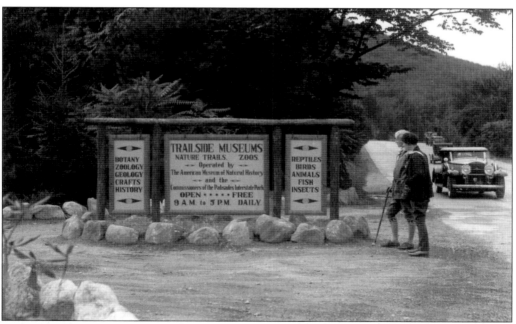

TRAILSIDE. As an outgrowth of natural history programs begun in 1920, the Trailside Museums and Zoo were created in 1927 to educate the public and further the cause of conservation. They were jointly operated by a partnership of the PIPC and the American Museum of Natural History until 1935, when the state assumed funding responsibilities. A short walk east from the playfield, Trailside was a unique addition to the recreation offerings at Bear Mountain.

WILLIAM CARR. From the outset, the director of the museum project was William H. Carr. Outdoor education was in its infancy, and Carr's creativity and resourcefulness set an example that even the national parks followed. Carr insisted that displays contain only those specimens indigenous to the area. He and his staff made many of the early exhibits by hand. Above, Carr is building the first snake house in 1927. One of his favorite teaching methods was the "tactile approach." Items were displayed so they could be lifted and handled. Snake demonstrations, petting, and feeding of some animals were carried out with supervision. Below, schoolchildren handle snakes as part of an educational presentation about 1942. Carr also found time to write scholarly papers, publish reports, host groups of teachers and scouts, and correspond with universities and libraries around the country.

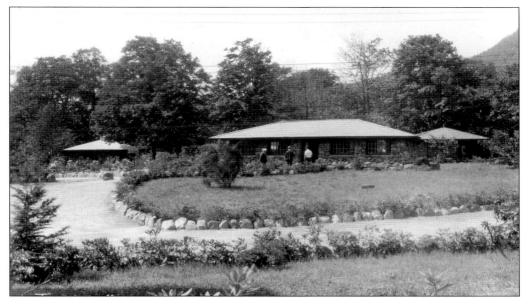

MUSEUM BUILDING. The first Trailside Museum building was completed in September 1927. Designed by master architect Herbert Maier, construction was supervised by Maj. William A. Welch, chief engineer and general manager of the park. Between 1932 and 1935, the WPA erected separate buildings for botany, geology, history, and nature crafts. They were constructed near the bridge tollhouse so as not to disrupt a previously built nature trail.

INFORMATIONAL FOOTPATHS. Two visitors read interpretive signs set into a birch log along one of the trails. The 57-acre outdoor education area consisted of trails, museums, and a zoo. Describing his project, Carr wrote, "Nature trails are informational footpaths leading through the woods and fields. Nature provides all the illustrations. Lettered guides, attached unobtrusively to objects in place, tell the story."

LABELS. Using a fountain pen and India ink, Marion Carr carefully prepares a label for the outdoor exhibit. She is seated on the porch of the Carrs' cabin at Trailside. The labeling of items along the trail took more than two years. Every sign was hand lettered and contained the name of the specimen and additional information related to taxonomy, commercial use, life cycle, or geographical distribution.

GEOLOGY BUILDING. Director William Carr and librarian Nina Thomas check sources on the identification of rocks and minerals in the mineral display. Since geology and mineralogy were an important part of outdoor education, a separate building was constructed to highlight those subjects. Specimens were placed in easy reach to be handled by interested visitors.

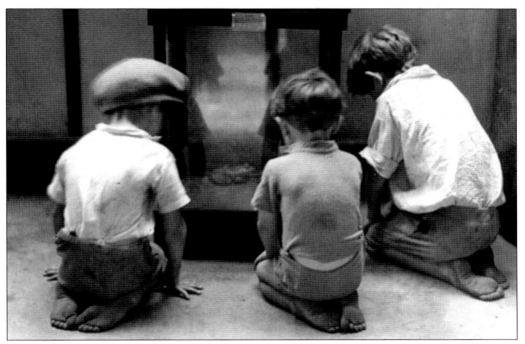

CONSERVATIONISTS, C. 1928. Three future conservationists carefully consider a bullfrog in the small animals museum that housed live specimens of fish, salamanders, and snakes. Exhibits varied but almost always included frogs, rattlesnakes, and copperheads.

BOTANY BUILDING. Exhibits in the botany building (above) were a constant source of interest to parkgoers. A museum motto was "Ecology and taxonomy go hand in hand." Consequently, local species were identified by their proper names in all displays.

SNAKE EXHIBIT. This father and daughter focused on the snake exhibit along the nature trail about 1929. As stated in an early annual report, one of the museum goals was "to provide an area where periods of leisure may be used to excellent advantage educationally."

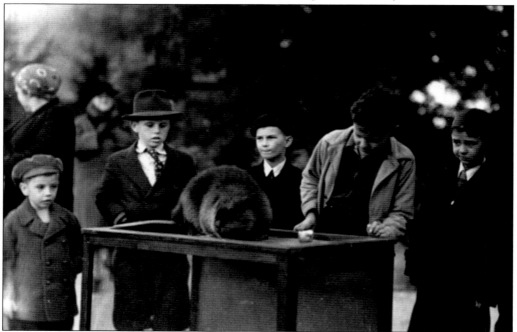

BEAVER EXHIBIT. Among the animals these curious fellows were able to see on the nature trail in 1941 were skunk, raccoon, fox, and this beaver. The fishpond, snake pit, duck pond, and turtle exhibit were particularly popular with children.

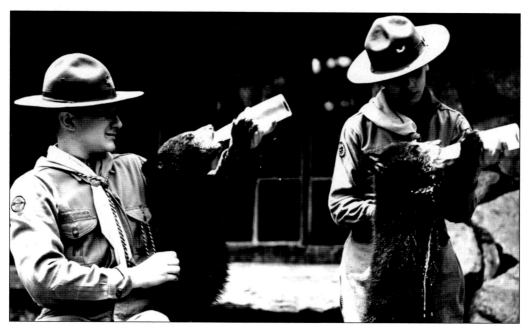

BEAR CUBS. Acquainting young visitors with animal life and stimulating interest in conservation have been goals of the Trailside Zoo since its inception. Early conservation practices encouraged interaction between humans and animals. Here two Boy Scouts demonstrate the care and feeding of bear cubs about 1960.

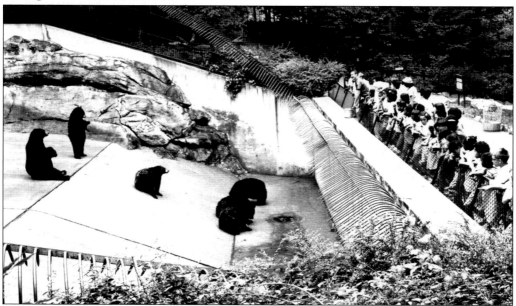

BEAR DEN. A perpetual favorite of zoo visitors has been the bear den. The bears, seen here in a 1962 photograph, seem to be equally fascinated with the visitors. Black bears were commonly found in the Highlands in early Colonial times and, after almost disappearing, have experienced resurgence in modern times. It is said that Bear Mountain got its name from the fact that it is shaped like a reclining bear.

APPALACHIAN TRAIL. Hiking the Bear Mountain section of the Appalachian Trail was a unique experience about 1928 when the photograph of these young ladies was taken. By design, the trail actually passed through the small animals museum. Part of the original concept of the Appalachian Trail was to have several Trailside Museums along its length.

TREE LECTURE. Sitting peacefully in the warm sunshine about 1926, a group of female campers is treated to a lecture on tree identification by a park educator. The Trailside staff regarded education as their central mission.

ELK HEAD. Since 1935, this stately bronze elk head, sculpted by Tiffany and Company, has looked out on the Hudson River from the nature trail. In 1919, a herd of elk was shipped from Yellowstone National Park to be settled in Harriman Park. For several years, two elk were exhibited at the Trailside Zoo but the elk did not thrive in the Hudson Valley and the herd died out. (Photograph by John Korbach, PIPC Archives.)

WINTER WALK. Parkgoers can walk the nature trails 365 days a year. In his 1936 *Ten Year Report*, William Carr summed up the essence of the Trailside Museums. "The fundamentals of life and living seem, somehow, to descend upon one who enjoys a peaceful contemplation of Nature far from the cities."

ELEANOR ROOSEVELT. In May 1933, Eleanor Roosevelt (second from left) unveiled a plaque on the geology trail in honor of Stephen Tyng Mather, first director of the National Park Service. She was joined by Secretary of the Interior Harold Ickes (left), who was the guest speaker, and Clara Mather. The National Park Service and the PIPC had a close, professional relationship.

WHITMAN STATUE. This statue of Walt Whitman was donated to Bear Mountain by Averell Harriman in November 1940 as a memorial to his mother. Created by sculptor Jo Davidson for the 1939 New York World's Fair, the statue was placed along the section of the Appalachian Trail that winds through the park. Pictured at the dedication are the speaker, Sen. Edmund Wakelee, joined by, from left to right, Laurance Rockefeller, Robert Moses, Harriman, and George Perkins Jr.

Ten

TIMELESS

THE INN. Blanketed under a fresh snowfall, the Bear Mountain Inn stands in rustic grandeur at the base of the mountain for which it is named. Services have moved or modified with the times, but the inn remains a timeless witness to the success of the PIPC's mission to rescue a piece of nature for the people and make it accessible to one and all. (Hansen collection.)

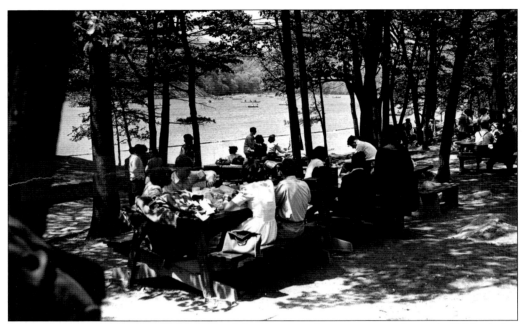

PICNIC. Picnicking continues to be one of the most popular activities at the park. Tables laden with treats and the smoky aroma of dozens of barbecues are part of the summer experience. Protected by the tall trees around majestic Hessian Lake, friends and families share food, laughter, and memories.

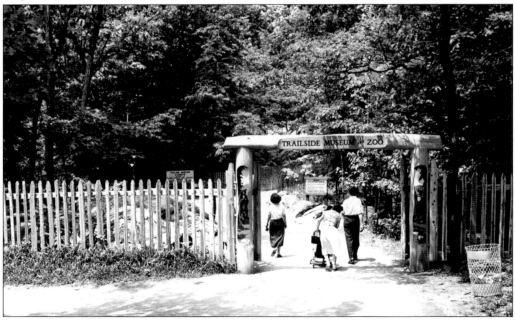

TRAILSIDE. Today the Trailside Museums and Zoo continue to interpret local wildlife, ecology, Colonial and Revolutionary history, and geology. They capture the attention and imagination of thousands of families, hikers, and travelers each year. Carefully lettered signs still educate readers about the natural wonders of the Hudson Highlands.

SWING TIME. The smiles and laughter of children have always been part of the Bear Mountain experience, whether on swings, trail, boats, or skis.

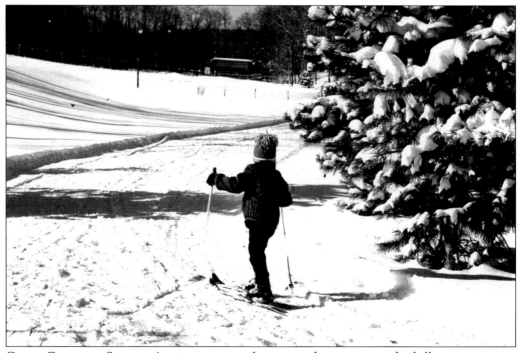

CROSS-COUNTRY SKIING. As winter graces the area and snow covers the hills, cross-country skiers of all ages take to the woods for an invigorating day in the crisp, cold, pine-scented air.

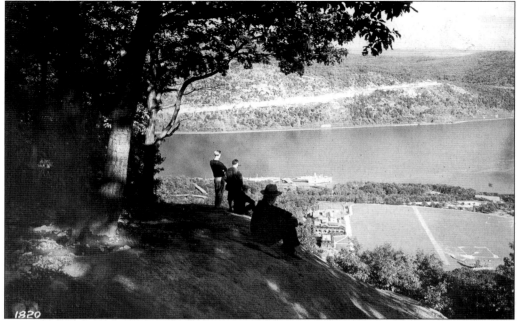

RIVER VIEW. Looking down from Bear Mountain, the view of the park, river, and opposite shore remains a sight of inspiring loveliness. (Hansen collection.)

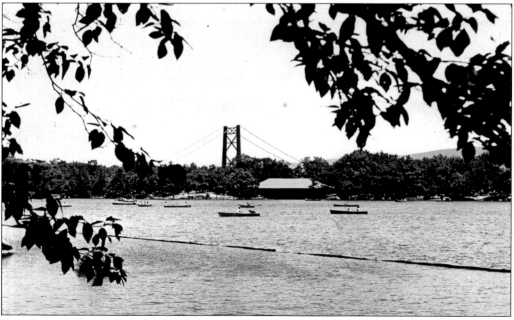

THE LAKE. Historian Arthur Abbott saw Hessian Lake as a connection between the early Native American inhabitants and the modern visitor. "Their bark canoes ruffled its mirror-like waters and shouts of merry laughter re-echoed along the wooded sides of Bear Mountain as do those of the day visitor now."

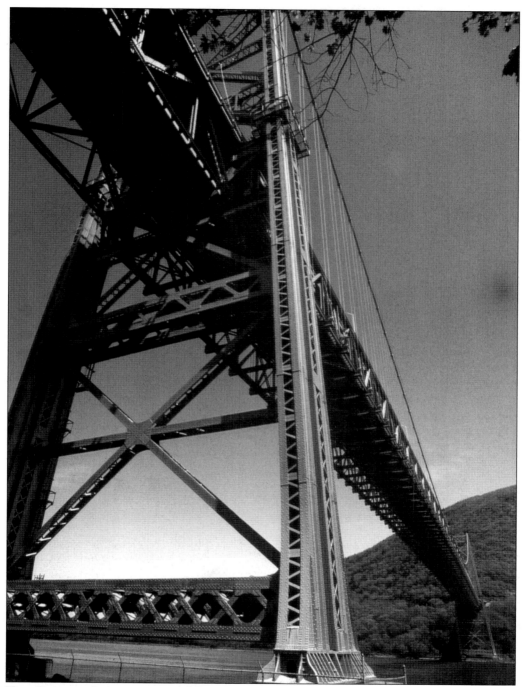

THE BRIDGE. A unique part of Bear Mountain's past, the bridge has enabled countless motorists to visit the park. As part of the Appalachian Trail, it has been the pathway for thousands of hikers. As it continues to be a major thoroughfare, it is in essence a bridge to the future. (NYSBA.)

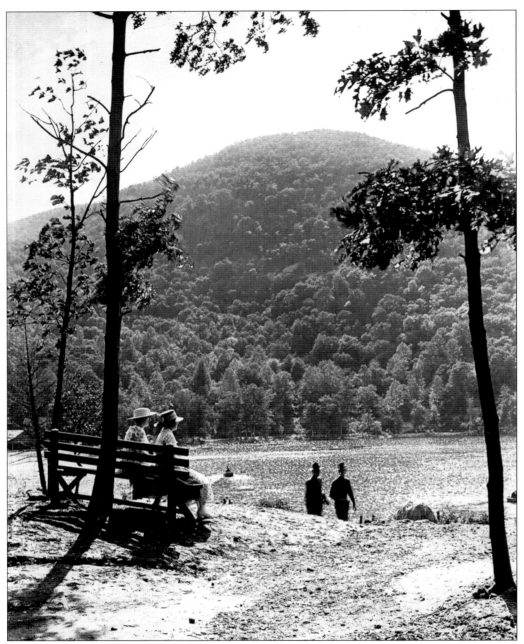

SUMMER DAY. Beside the lake on a summer day, sunlight sparkling on the water refreshes the spirit. "The region is nearly perfect now," wrote William Howell. "Nothing is more quietly beautiful than Highland [Hessian] Lake lying near the base of Bear Mountain, with its unpathed woods."

BIBLIOGRAPHY

Abbott, Arthur P. *The Greatest Park in the World*. New York, NY: Historian Publishing Company, 1914.

Bear Mountain Bridge. Highland, NY: Bear Mountain Bridge Authority, 1999.

Binnewiess, Robert O. *Palisades: 100,000 Acres in 100 Years*. New York: Fordham University Press, 2001.

Carr, William and Richard J. Koke. *Twin Forts of the Popolopen*. Bear Mountain, NY: Bear Mountain Trailside Museums, 1937.

Focht, Jack., ed. *Trailside Papers*. Bear Mountain, NY.

Howell, William Thompson. *The Hudson Highlands*. New York: Walking News, 1982.

Kaminski, John P. *George Clinton*. Madison, WI: Madison House Publishers, 1993.

Lenik, Edward. *Iron Mine Trails*. New York: New York–New Jersey Trail Conference, 1996.

Lossing, Benson. *The Hudson from the Wilderness to the Sea*. Troy, NY: H. B. Nims, 1866.

Mandigo, Helen. *History of Doodletown*. Bear Mountain, NY: PIPC Press, 1941.

Muir, John. *Edward Henry Harriman*. Garden City, NY: Doubleday and Company, 1912.

Myles, William J. *Harriman Trails*. New York: New York–New Jersey Trail Conference, 1991.

Palisades Interstate Park Commission Annual Reports 1900-1920. Bear Mountain, NY: Palisades Interstate Park Commission.

Palisades Interstate Park Commission Second Century Plan. Bear Mountain, NY: 1990.

Ransom, James M. *Vanishing Ironworks of the Ramapos*. New Brunswick, NJ: Rutgers University Press, 1966.

Ringwald, Donald C. *Hudson River Day Line*. Berkeley, CA: Howell-North Books, 1965.

Stalter, Elizabeth. *Doodletown*. Bear Mountain, NY: Palisades Interstate Park Commission Press, 1996.

Zimmerman, Linda, ed. *Rockland County Century of History*. New City, NY: Historical Society of Rockland County, 2000.

www.arcadiapublishing.com

MAP SEARCH

Discover books about the town where you grew up, the cities where your friends and families live, the town where your parents met, or even that retirement spot you've been dreaming about. Our Web site provides history lovers with exclusive deals, advanced notification about new titles, e-mail alerts of author events, and much more.

MADE IN THE USA

This book carries the accredited Forest Stewardship Council (FSC) label and is printed on 100 percent FSC-certified paper. Products carrying the FSC label are independently certified to assure consumers that they come from forests that are managed to meet the social, economic, and ecological needs of present and future generations.

FSC
Mixed Sources
Product group from well-managed forests and other controlled sources

Cert no. SW-COC-001530
www.fsc.org
© 1996 Forest Stewardship Council

Find Your Place in History.